EDWARD ARDIZZONE CBR, RA (1900-1979) was born in French Indo-China (now Vietnam) to an English mother and French telegraph and wireless engineer of Italian parentage. The family came to England in 1905, and in 1920 his father bought a house in Maida Vale – an area of London that Ardizzone was to make his own and is the setting of many of the pubs illustrated in *The Local*. He went to Clayesmore School, worked briefly as a clerk, and attended evening classes at the Westminster School of Art. In 1927 he became a full time artist, marrying Catherine Anderson two years later, with whom he had three children. In 1930 a meeting with Maurice Gorham, a childhood friend, resulted in a commission to provide drawings for *Radio Times*. His paintings and watercolours were regularly exhibited throughout the 1930s, and in 1936 he published *Little Tim and the Brave Sea Captain*, the first of the 'Tim' books. In 1940 he was appointed an Official War Artist, serving in France, North Africa, Sicily, Italy, during the Normandy landings and in Germany – a period covered in Malcolm Yorke's account of Ardizzone's work as a War Artist, *To War with Paper and Brush* (2007). After the war he joined the staff of Camberwell School of Art, later becoming a tutor at the Royal College of Art, and dividing his time between Maida Vale and a cottage in Kent. Altogether he illustrated well over 100 books. As well as Maurice Gorham, his collaborators included James Reeves, Graham Greene and Eleanor Farjeon. *Tim all Alone* (1956) was the first book to win the Kate Greenaway Medal. To this day, many of his books remain in print and his reputation as one of Britain's most popular artists and illustrators continues to grow.

MAURICE GORHAM (1902-1975) was an Irish journalist and broadcasting executive who was educated in England at Stonyhurst College and Balliol College, Oxford. In 1926 he joined the BBC to work on the *Radio Times*, serving as its Editor from 1933 to 1941. His other posts included Director of the BBC's North American Services, Director of the BBC Allied Expeditionary Forces Programme, Director of the new BBC Light Programme and, briefly, first post-war Director of the BBC Television Service. He returned to Ireland in 1947, and as well as writing a number of books on broadcasting and Irish life, served for six years as Director of Radio Éireann. As well as *The Local* (reissued in 1949 as *Back to the Local*), Gorham and Ardizzone collaborated on *Showmen and Suckers* and *Londoners* (both 1951).

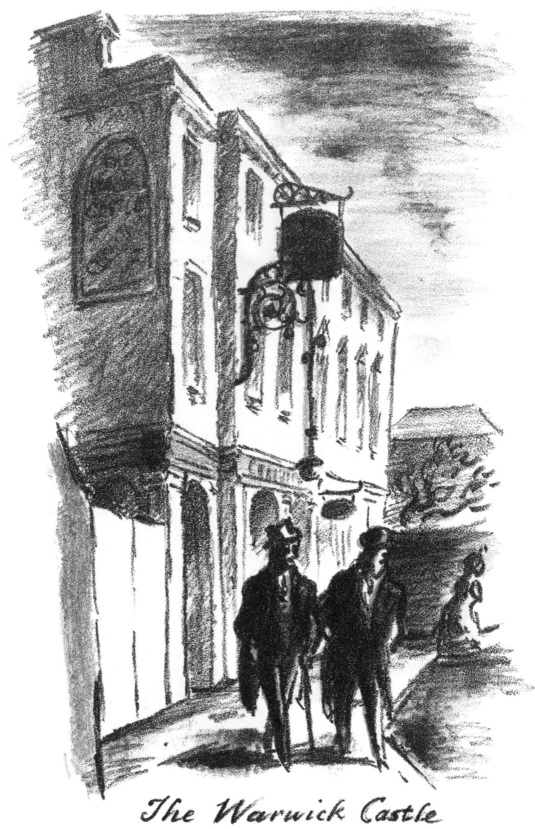

The Warwick Castle

The
LOCAL

Illustrations
Edward Ardizzone

Text
Maurice Gorham

INTRODUCED BY
Malcolm Yorke

LITTLE TOLLER BOOKS
an imprint of THE DOVECOTE PRESS

First published in 1939 by Cassell & Co. Ltd
This new edition published in 2010 by Little Toller Books
Stanbridge, Wimborne Minster, Dorset BH21 4JD

ISBN 978-0-9562545-9-7

Illustrations © The Estate of Edward Ardizzone 1939
Text © Maurice Gorham 1939
Introduction © Malcom Yorke 2010

'Darts at the Alfred' on page 13 © Edward Ardizzone
from *Back to the Local* (1949) Re-published by FaberFinds in 2008
Permission granted by the Artist's Estate

We have made every reasonable effort to trace the executors of
Maurice Gorham's estate, and would welcome any further information

Typeset in Monotype Sabon
Printed in Italy by L.E.G.O.

All papers used by Little Toller Books and the Dovecote Press
are natural, recyclable products made from wood grown in sustainable,
well-managed forests

A CIP catalogue record for this book is available
from the British Library

1 3 5 7 9 8 6 4 2

Contents

Illustrations

Introduction

MALCOLM YORKE

WHEN THIS LITTLE BOOK was published Edward Ardizzone (1900-79) was aged thirty-nine, a married father of three struggling to establish himself as an artist and illustrator. His studio was in the family home at 130 Elgin Avenue, Maida Vale, a three storey terrace house his father had bought in 1920 to house his five offspring and subsequently their partners and children. Each day Edward would leave his drawing board for a lunch break in a nearby pub, and perhaps return for another pint or two in the evening after his day's work. On many of these excursions he was accompanied by an Irish friend from childhood, Maurice Gorham (1902-75) who was an Oxford graduate and – very usefully for Edward – Art Editor of *The Radio Times*. Their first book together was, therefore, based on many happy hours of informal research. Later they would collaborate on two more books with London themes.

The artist was a rotund, benevolent figure and only his surname hinted at more exotic origins. His father, Auguste, was an Italian who had left Bari to become a French citizen in Algeria. His work in telegraph and wireless communications took him all over Asia so that his London-born but Scottish wife gave birth to Edward in Haiphong, in what is now North Vietnam. He and two younger sisters returned to England for their education in various towns in the southern counties, but it was only when he moved to London

in 1918 to become a clerk that Edward began to draw seriously.

He attended evening life classes with Bernard Meninsky, but otherwise he evolved his own unique style, which was neither academic nor avant-garde. He made the observation of ordinary people in their everyday settings his sole subject matter. Like the great Thomas Rowlandson before him he was the amused but unjudgemental chronicler of the small human dramas around him. From his second floor window he could observe and draw the local prostitutes, the larking children and carol singers; or stroll to the park to sketch callipygous lady cyclists and muddy footballers; then on to the canal to observe the anglers and furtive lovers before an evening in the raucous local music hall. However, the pub was his favourite milieu for people-watching. He would make scrappy notes on cigarette packets or beer mats and work them up from memory back in the studio.

Ardizzone became the master of stance, gesture, profiles, dramatic lighting and the conveying of emotion by the minimum of means. The close-up was avoided and the back view or silhouette preferred to the full face – yet we could surely provide thought or speech bubbles to many of the visages here, though they are little more than two dots and an expressive dash. His favourite tools were pen and ink with watercolour washes, but for *The Local* he used the less familiar lithography with its softer lines and stronger colours, printed at the famous Curwen Press.

Though both men were under forty there is already an old-codgery nostalgia about this book. They moan that too many of their refuges from home life are being tarted up by developers ('all grained oak and linoleum'), while slot machines and the newly fashionable darts attract the young with 'their penetrating voices and scarlet fingernails' and even children are creeping in where pubs have gardens. Being a 'regular' is a serious vocation and these distractions are not welcome since he is there to enjoy

the company (especially the barmaid's, though even they were declining in quality) and above all the drink. There is a helpful Glossary which is even more crucial to the modern reader since who now drinks mother-in-law (stout and bitter), dog's nose, red biddy, porter, mild or wompo? Canned beer had not yet caught on, lager was not popular, ice was still a luxury and if wine was available 'it is not always wise to drink it.'

The publisher and I did our little research crawl round Ardizzone's patch but we were disconcerted to find from the Internet that there are still 1081 pubs within three miles of Maida Vale tube station! We settled for a smaller sample of which the Prince Alfred was the most remarkable (see page 37). The cockatoo is no more, the dartboard has disappeared and the clock has stopped but otherwise little has changed since 1939, or indeed since 1862 when it was built and named after Queen Victoria's youngest son. The five bars are still intact as are the snob screens, tiles, etched plate glass, plasterwork and fantastically ornate woodwork.

The nearby Windsor Castle might be one of those intimate 'muse' pubs Gorham loved so much. It has a tiny bar, no food and no gimmicks. The larger Warwick Castle has a façade festooned with fragrant hanging baskets beneath which the leper-like smokers indulge their lonely vice. Inside there is a superior collection of art on the walls but a pleasantly primitive Gents. Biggest and most pretentious of all is The Warrington (see page 35), with its eclectic architecture ranging from Egyptian to Art Nouveau and its armorial bearings proclaiming *Constantia et Labore*. Inside marble pillars, Mucha-like murals and the staircase up which the tarts made their giggling way in several of Ardizzone's pictures are all still intact.

The Warrington is now a celebrity chef's gastro-pub. Gorham's bar food was 'a cut from the joint and two veg', a cheese sandwich,

or a 'cold dog.' What would the authors make of the chichi flavours of tarragon, fennel, marjoram, saffron, chicory, paprika and garlic now on offer and the Thai, Greek, French, and Indian dishes chalked up on blackboards in many of their old haunts? Not much, one suspects. They might also deplore the omnipresent TVs, the withering away of games, the weekly quizzes, the short-stay foreign bar staff, the lack of live musicians, the sloppy dress codes and the lack of a good dense fug of smoke.

The war arrived even before *The Local* was in the shops and potential readers were already groping towards their pubs through the blackout clutching gasmasks. Gorham soon sailed off to become the Director of the BBC's North American Services while Ardizzone had the time of his life as a War Artist. His rank as a non-combatant Captain meant he was paid enough to clear his debts and his widely reproduced drawings of the Blitz, the Home Guard, bomb disposal crews, the Battle of El Alamein, the invasion of Sicily, Algiers, the Italian campaign, the Normandy landings, the drive into Germany and the freeing of Denmark made his lasting reputation. The same nervy multiple line, studied composition and near-caricature depictions of his fallible fellow men (and women) could be adapted to depicting mutilated corpses, looting soldiers, exhausted refugees or officers enjoying the raffish charms of Cairo.

Asked in old age about the effects of the war he replied: 'I don't think it changed me as an artist because I've always been interested in people, not necessarily soldiers and people being killed, but in people. I love women and I like drawing tarts, and I like drawing pubs. I like drawing everything you know, so it made no difference in that sense.'

While the two men were away Cassells, their publishers, had been bombed and the litho plates and unsold copies of *The Local* destroyed. The firm Percival Marshall then brought out a new

edition in 1949 called *Back to the Local* with a slightly modified text by Gorham and black and white line drawings by Ardizzone. However, *The Local* remains the volume collectors covet with its vibrantly coloured lithographs and its celebration of that uniquely British institution 'the local', and the 'modest and not altogether useless career' of being one of its 'regulars'.

MALCOLM YORKE is the author of *To War with Pen and Brush* (Fleece Press 2007), an account of Edward Ardizzone's career as an Official War Artist.

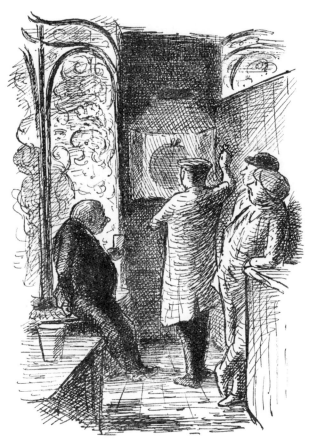

Darts at the Alfred

Preface

MAURICE GORHAM

THIS IS A BOOK ABOUT THE PUBS OF LONDON. A book with such a subject will seem, to those who know their pubs, to need justification – not to say apology – at the start.

There are nearly four thousand pubs in London, and they are all different. Old and brand new, large and small, prosperous and neglected, smart and shabby; pubs in select neighbourhoods catering for a 'nice class of people', pubs in frowsy neighbourhoods frowned upon by the Licensing Bench. There are pubs that have taken their place among the sights of London, and pubs that are unknown two streets away.

Nobody can profess to know all the pubs of London. Ardizzone and I certainly make no such claim. We cannot even feel confident that we know enough pubs to be able to generalize about them all. Among the few thousand that we have not come across there may be an exception to every rule.

But all these pubs have one thing in common. Every one is somebody's local. Every one has its regular customers, who use it for some reason in preference to other pubs (for in Central London nobody can be very far from two pubs at least). Even the sightseers' pubs have their regulars; the Cheshire Cheese in Fleet Street, which is the sightseers' pub *par excellence,* may depend upon visitors for its restaurant revenue, but the bar itself is used regularly by journalists, advertising men, photographers – all sorts of local

workers who would never think of ordering the famous pudding, nor derive any satisfaction from sitting in Doctor Johnson's seat. The most metropolitan pubs on circuses – the sort that bus-stops are named after – and the busiest station bars have their regulars: customers who ask for 'the usual', and call the barmaids by their first names.

All this book is trying to do, therefore, is to show some of the characteristics of the London pubs as we have found them in our own locals, and to remind any readers who need reminding what a very useful institution the local pub can be.

In passing, there is no reason why one person should not have more than one local. In Central London, where pubs are plentiful, it is always possible to have three or four near your home, and three or four more near the place where you work, apart from any that happen to be conveniently situated, for instance at bus-stops or stations, on the way home. How many pubs you use regularly depends upon your own taste and fancy. If you want to become an intimate of the house it is better to use as few as possible so as to use those few more, but if your ambition is merely to be nodded to when you come in, that degree of familiarity can be attained in a score of houses without any danger of drinking yourself to death. Even in these days of changing managers and ephemeral barmaids most of the people who work in pubs are fairly observant, and it is sometimes almost embarrassing to receive a hearty welcome in a pub that you have been neglecting for years.

OTHER PEOPLE'S LOCALS

The local pub can be a club, a refuge, a home from home. But an inquiring spirit will feel, sooner or later, the stirrings of desire for discovery. Other pubs tempt you; you get off the bus at a different place to try the pub you have always seen and never visited; you

let your walks lead you to pubs that you have passed when you were in a hurry, or when they were closed; you begin to be curious about the pubs of the West End, or the East End, as the case may be; you have heard that an out-of-town brewery has a London pub where the bitter is unusually brilliant, and you decide to go and find it. You make many discoveries and draw many blanks. If the discoveries outnumber the blanks, you reach the condition when you collect pubs hopefully, as a gourmet collects restaurants, and a pub you have not been to becomes a challenge to go in.

This, of course, is a long job, if you are not to neglect your locals whilst you explore. And it is an endless job. Apart from the sheer number of the pubs that you have not yet visited, you leave behind you an ever-increasing list of pubs to be visited again. There are those you found good enough to visit for pleasure, those you found bad enough to make it worth visiting them again to see if they were really so bad as all that, and those that have changed. Rebuilding and internal reconstruction alone keep the inquiring spirit fairly busy nowadays.

The rewards of exploration, however, are high. Pubs vary so prodigiously, and so unexpectedly. Neither neighbourhood nor exterior is any guide to what is within. A house with a long imposing façade may turn out to be only a few feet deep; a house with a modest entrance and a narrow frontage may extend back to the next street, as do some of the houses round Fleet Street and the Strand. You can find plebeian houses in expensive neighbourhoods, though less frequently than you could a few years ago, for the brewers have discovered them too and are rebuilding them to make their revenues more consistent with their ground rents; and you can find the neatest and snuggest of houses in the dingiest streets. Sometimes an ancient exterior conceals a modernized bar all grained oak and linoleum; less often, a hideously modernized front leads to a pleasantly unaffected bar.

Then there are the specialized pubs, which can sometimes be expected from their surroundings, but more often not. You would expect, for instance, to find a Continental atmosphere about the Swiss Hotel in Old Compton Street, but there is nothing about the York Minster in Dean Street, round the corner, to prepare you for the superb moustaches of the proprietor, and the fact that more than one language is spoken behind the bar. In your wanderings you will find yourself in pubs especially patronized by waiters, artists, medical students, musicians, banknote engravers. There are pubs around Portland Place where you will feel lost if you do not know the jargon of the rag trade, the used-car market, or the BBC (and there is one pub where you will hear little but the even more esoteric jargon of the IBC [International Broadcasting Corporation: now the World Service]). There is a pub in Great Windmill Street where everybody who comes into the Saloon Bar seems to be in the dance-music business. Of all the pubs around Victoria Station, the Grosvenor Basin in the Wilton Road is the one where the couriers congregate and exchange their cosmopolitan Cockney. ('Wotcher, Bert. Where you been keepin' yourself? 'Aven't seen you since Gawd knows when. Lemme see – Niples wasn't it, last June – or 'Eliopolis?') There is a pub near the Embankment Gardens where the bandsmen used to change after their public concerts; they would enter in full regimentals and, after a good deal of furtive scuffling among the hat-pegs, leave again in civilian attire. At the Victoria Stores, opposite the stage door of the Victoria Palace, you can see the chorus boys, all made up for the second house, struggling to the bar through the press of broad-backed draymen from Watney's brewery round the corner, on a Friday night. The pubs of Covent Garden, of course, are full of market porters in the Public Bar and fruit salesmen in the Saloon, but the Nag's Head has the Opera House custom as well. There is a pub near Cambridge Circus where you will always find Africans and West Indians, and there was a

pub not far away where you would find car thieves who stopped talking when you went in; but they have closed it down.

These highly specialized pubs are comparatively rare, though you may stumble casually on one of them at any time. But you can always count on differences of architecture, personnel, and even drinks – for different houses can serve very different versions of the same brew.

EXTENSIVE AND PECULIAR

Mr Weller's knowledge of London was extensive and peculiar, as he showed when Mr Pickwick expressed a desire for a glass of brandy-and-water warm after his interview with Dodson and Fogg. He replied, without the slightest consideration: 'Second court on the right-hand side – last house but vun on the same side the vay – take the box as stands in the first fire-place, 'cos there an't no leg in the middle o' the table, wich all the others has, and it's wery inconwenient.'

That is the ideal, but Sam's education had been unusually complete, as his father remarked on that very occasion. Still, it is uncommonly useful to have a local wherever one happens to be, especially if one can feel certain that it really is the best pub in the neighbourhood, and not merely the best that one knows.

Some of the nicest pubs in London are well hidden from the casual view. They lurk up mews, down alleys, everywhere off the main streets. One of the chief interests of exploratory walks is finding them and noting them for future use – for nobody can tell when and where he will meet his Dodson and Fogg.

Sometimes, indeed, these by-street pubs are indispensable, when the main streets have no pubs. Few of London's main thoroughfares are so barren, but there are some. Park Lane, for instance, has no pub between Marble Arch and the fountain, and if you then

follow the bus route down Hamilton Place you will miss the Rose and Crown that lies in the narrow termination of the true Park Lane. Yet from Mount Street down, almost any detour would have brought you to a pub – either the Audley Hotel, the Punch Bowl in Farm Street, the Red Lion in Waverton Street, the old Pitt's Head, the new Shepherds, or the original Mayfair Hotel.

If you cross Hyde Park Corner and go on towards Victoria, you come to another bad patch. Grosvenor Place has not a single pub. Go a hundred yards or so to the right down Halkin Street, however, and you can walk down a veritable avenue of pubs. Between Halkin Street and Wilton Street there are no fewer than five pubs, all small, local, pleasant, giving a choice of four different brews. Until the latest wave of demolition you could go on through the back door of the Feathers and emerge in Hobart Place, if you were careful when opening the door to avoid getting a dart in your eye; but the Feathers has now disappeared, and if it comes back it will probably have no back door.

REBUILDING BLUES

This question of rebuilding demands a passing mention, as it is one of the ever-present factors in the pursuit of pubs. Here the sentimental pub-goer is opposed to all the interests – brewer, Bench, publican, and, very often, staff. The modern café-pub, clean, light, airy, spacious, where the man can bring his family to sit at small tables and drink soft drinks if they so prefer, has the blessing of modern thought. It is left to the sentimentalists, like Ardizzone and me, to reply that the modern pub may be better, but the old-fashioned pub was nicer; that we do not want to sit at small tables and pay a waiter to bring us our drinks; that the man seemed to have no scruples about bringing his wife to the old-fashioned pub, and as for the children, we all go to the pubs to get away from

them; in short, that we have seldom known a pub to be improved by rebuilding, and we have known plenty to be spoiled.

It all depends on what you want, of course. The brewery wants a good-class house that will attract the young people and provide a big turnover. The manager wants a prosperous house that will ensure his job. The staff want decent facilities behind the bar (though many old-fashioned pubs had them, and some modern ones have not). But it is a bitter moment when the manager shows you the plans. I know one very good landlord who had a house that looked just as it must have looked in Dickens's time; in fact you could imagine Bill Sikes starting up from the table in the little back room, with his dog slinking out at his heels. It was dreary, certainly, but it had character, and the landlord and the drink were good. Then the brewery planned to rebuild. The neighbourhood was improving and they wanted to expand. The landlord was delighted, and from common politeness I had to admire the plans. That house is now light, clean, airy; it has a model restaurant and a ladies' lavatory (which is a convenience in every sense of the word); the landlord and the drinks are still good. But it has lost its savour. Apart from the landlord, it might be any other house rebuilt by the same brewery in the last ten years.

There is, luckily, a fascination in seeing the actual process of rebuilding at work. Take the case of the Two Chairmen in South Bruton Mews.

A few years ago this was a small, creeper-clad corner pub in a Mayfair mews, with a private bar served through a hatch, and outside it a sort of glorified bulkhead in which a cobbler worked, this being famous as London's smallest shop. That was when Berkeley Square was still Berkeley Square. Then came the shadow of Berkeley Square House. In a week the mews had died. Demolition began on all sides – the thrilling business of pick and mattock, lorry and crane, always absorbing to watch, though usually disastrous in

final result. For a time the pub prospered, crowded with labourers whose throats were parched with brick-and-mortar-dust. The boom lasted until, suddenly, as these things always happen, the pub disappeared.

For a further spell the old fascia-board still showed over the hoardings, behind the demolition cranes. But this was a radical rebuilding. The very footway was being diverted; South Bruton Mews was changing to a new Bruton Lane. There is a new custom now about licences in abeyance, and I thought the pub had gone. Then one day a wooden hut arose at the end of a causeway, built out on piles in the midst of the excavations – which, as with all modern buildings, went well below the soil. It looked like a builders' hut, until one day men crawled along it, scaled the roof, and hoisted the old original Toby sign.

From that time onwards, throughout the rebuilding, the Two Chairmen plied its trade. It was hard to get to, sometimes, when the blackboard saying 'PUB' – pointed to a narrow path of planks laid in deep mire; but at the end of the path there was the little shack, with a few barrels behind the makeshift bar, and a dartboard for amenities. And all around it rose the ponderous bulk of Berkeley Square House.

At last the change came. Suddenly the pub appeared at a new entrance: part of the main fabric of the new block. At first it looked less like a pub than any other in London. There were doors marked Public Bar and Saloon Bar, and the name of the Two Chairmen – no brewers' sign. Inside it was large and airy and unadorned. It had not yet been discovered by the officials of the Air Ministry. It was quite a nice pub.

But change had not yet done with it. First there were the Neon signs; then a signboard appeared – the two chairmen carrying their sedan chair, though it was a sedan chair that Hercules and Samson could not have carried without spilling its occupant out. The inside,

too, began to sprout. The bar aperture was partly closed by giant beams that rang hollow to the knuckle; the doors went medieval; Tudor roses sprang from the walls. A patch of stonework (also drumlike to the knuckle) surrounded the fantastic sign. The pub became a class pub, fit for the Air Ministry. The management, I know, are sincerely proud of the change. Maybe they are right.

THE DRINK QUESTION

This plaint against rebuilding is peevish stuff. It is open to any advocate of progress to reply that if you want dirty old pubs you can still find plenty. That is true enough.

A more practical question is what to drink in your pub when you have found it, assuming that it is not your own local and you have not learnt by experience what they keep best.

It would seem impertinent to write about tastes in drink if it were not that so many pub-goers never attempt to plumb the resources of the pubs. I have met bitter-drinkers who had never tasted Burton, and old habitues of the Saloon Bar who asked whether old-and-mild came out of one tap or two. That is the only excuse for the notes on drinks that appear in irritating detail in the Glossary at the end of this book.

One explanation that is necessary is that draught beer is, on the whole, the staple drink in the pubs, and that this drink, in all its species, varies more than any other, not only from brewery to brewery, but from pub to pub. It is, therefore, the drink about which the pub-goer can afford to be most knowledgeable. A bottled Bass, Worthington or Watney (to mention only three brands) should not vary very much wherever you get it. A branded Scotch should vary even less, and wine in pubs is, speaking generally, a thing to avoid. But the draught beers take knowing. This, again, is an endless study. Houses sometimes change their brewers; breweries amalgamate;

23

and the keeping and serving of the beer are almost as important as the brewing, so the quality in any pub can change with a new landlord, or even with a new girl behind the bar.

Personal taste counts for so much that it would be foolish to give any opinions on drinks or brews. The facts are that pubs serve any or all of the following on draught: mild ale, bitter, Burton, Scotch Ale, stout, strong ale or barley wine (apart from cider and lager, and sometimes draught spirits and wine). Sometimes they keep more than one quality of some of them – a special bitter or a special ale. There are a dozen or so big brewers who own strings of London pubs, and a fair number of out-of-town breweries own occasional houses as well. Between the different breweries and the different brews you have enough variety to suit any tastes. In my own case, I favour Guinness's stout wherever it is well kept, Younger's Scotch Ale, Benskin's or Simonds's bitter (though both these are rare brews in London). Otherwise I go for the old-and-mild, or strong-and-mild when they keep strong ale on draught. Ardizzone is a bitter-drinker by preference. The next person will again have different tastes.

Generalizing from the particular is a vice from which the pubs have suffered enough. The title of this book was chosen to preclude that, but generalizations creep in. Readers are asked to overlook such transgressions and take the book as a sincere tribute to all the locals where Ardizzone and I have had so many pleasant times.

THE LOCAL

The Regulars

EVERY PUB IS SOMEBODY'S LOCAL, and every one has its regulars.
They may be lunch-time regulars who work near by, or six
o'clock regulars who look in for a quick one on the way home from
work and regularly miss two or three trains. There are West End
pubs where businessmen spend their evenings so regularly that their
wives ring up for them and the barmaid has to send them home.
But the most genuine regulars – the people who are really intimates
of the house – are to be found in the small neighbourhood houses,
just round the corner from where they live.

You see them ensconced in the corner by the partition, deep in
conversation with the landlady when you come in. The conversation
is deep enough to survive interruptions, and the landlady will serve
you, exchange a few words, and then return to the corner, lower
her voice, and carry on where she left off. The real regular is one of
the family. There is nothing he does not know about what happens
in the house.

As a regular myself, I have heard more about the affairs of licensed
houses than I know about any of my friends. I have followed the
career of a landlady's daughter from childhood to marriage, with
photographic illustrations, without ever seeing the girl. I have heard
the full account of another daughter's motor smash: a brilliant bit
of narrative, reaching the climax when the landlady said, 'And
what do you think they found in her jaw?', rang up 'No Sale' on
the cash register, and produced with triumph a large iron screw. I
have heard the confidences of a discharged barmaid in a West End
Dive, who had called to settle accounts with the manager. 'He's
hiding in the Gentlemen's, the dirty rat, but I'll get him if I have to

wait here all night.'

Nothing much is demanded of the regular except to come regularly and show himself interested in the pub's affairs. He need not even drink very much. Most of the regulars are leisurely, even reluctant drinkers. They make a half-pint last a surprisingly long time.

Of course, this business of having regulars cuts both ways. There are houses where you feel embarrassed if you are not a regular, and even houses where the occasional visitor has difficulty in getting served. But these very clannish houses are mercifully rare. In general you can get on good terms with the regulars in a very few visits, and even if you are quite unknown the presence of the regulars in their corners is a tranquillizing influence on the house. This is especially so on Sunday mornings, when the regular customers muster in full force. The Sunday morning walk, beginning shortly after twelve and ending up in the local when they open at twelve-thirty (which is the most general time), is one of the great institutions of the ordinary man. The two gentlemen pacing back from the Warwick Castle in the frontispiece (obviously on a Sunday morning) are as good regulars as the two in the Hero of Maida in the picture facing this page.

Peaceful and inoffensive (for the most part), the regulars would seem to have no enemies. But they are in danger, many of them. They are the chief victims of the rebuilding craze. When a nice old-fashioned pub is pulled down and turned into a cross between a roadhouse and a sanatorium, it is the regulars who suffer. Like fish out of water they try to adapt themselves to the new environment and fail. The more regular they have been, the harder it is for them to go elsewhere. It is a sad ending to a modest and not altogether useless career.

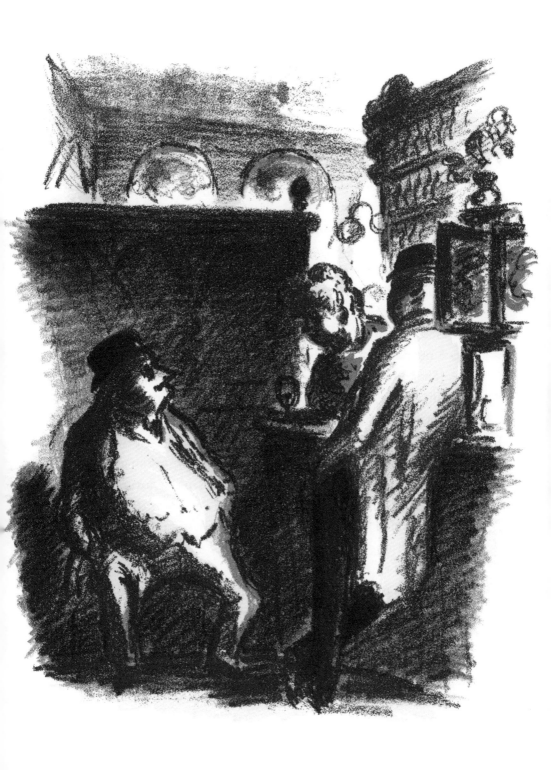

The Regulars at the Hero

Barmaids Old and New

IT MAY BE ONLY INCREASING age that makes me feel that barmaids, as a factor in the attractiveness of particular pubs, have fallen right away in the last ten years; but I doubt it. I fear that it is an objective fact.

My own pub-going days date only from after the War, and, no doubt, older drinkers will tell me that the barmaids of that period had already lost their glory. Yet until a few years ago they still had survivors. The ample bosom clad in black satin, the artfully-wrought pile of peroxide hair, the fingers all covered with diamonds (as W.W. Jacobs put it), lasted until my time. These were the barmaids of tradition, the confidential barmaids to whom the customers whispered over the bar, the haughty barmaids who could freeze the insubordinate customer with a look, the dominating barmaids who could quell a riot with a word, the tolerant barmaids who could listen unmoved to talk of the most doubtful description and then turn in a flash into highly virtuous barmaids who would order the loose-talker outside. And when they ordered anybody outside, he would go.

These massive and powerful personalities were, it is true, a survival. The post-war barmaid tended to be younger, slimmer, smarter. But she was still an attraction. Her appearance alone brought customers, and her conversation kept them. You had to be mentally on your toes to keep pace with her.

In those days some houses specialized in personality barmaids. It is true that they were not all pubs. Some were mere bars. Rule's, for instance, in Maiden Lane, had a tradition of elegant barmaids, founded on the undoubted fact that one of their barmaids went to

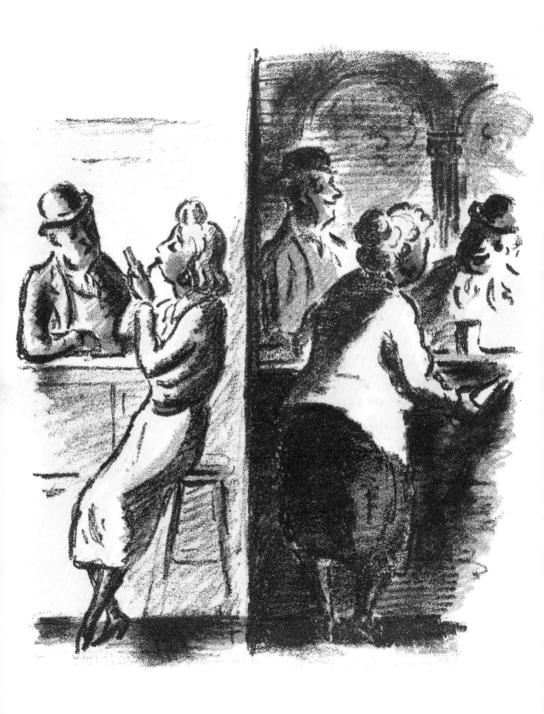

Barmaids Old and New

New York and joined the Ziegfeld Follies, but maintained by a long series of barmaids who were beautiful and by no means dumb. I cannot remember in what year Rule's shortened their bar and experimented with a male cocktail-shaker, but that date seemed to me to mark the passing of an age.

There were, of course, pubs with the same tradition. The Cheshire Cheese is one, and it still survives. Some new houses, like the Crown in the Bayswater Road, seem always to have smart barmaids; the new Shepherds in what is now Hertford Street (formerly the Chesterfield in West Chapel Street) has them; so has the Mayfair Hotel in Down Street. The bar in St. Martin's Lane, once George Mozart's, now Garrett's, had them when last I was there.

But nowadays you have to add 'when last I was there'. In general, the better-looking the barmaid, the less long-lived. If they don't quarrel with the manager, they quarrel with the manageress. They are here today and gone tomorrow. What is more, they seem to go completely. Perhaps they get married. They do not go where the customers can follow them, as they used to do in the days when a new barmaid at the Tivoli brought a lot of familiar faces from the Queen's.

The eclipse of the barmaids may be a good thing morally, ethically, and socially. The only thing I object to is that it does not mean better service in the pubs. The old-fashioned barmaid may have been there to attract men, but she knew how to do it, and one of the ways was to ensure the comfort of everybody who entered the bar. In other words she was anxious to please.

As for the black-calico-jacketed barmen, the dirty-white-jacketed waiters, who disfigure many modern bars, the only thing that can be said about them is that people must be terribly fond of drink to deal with them at all.

The Saloon Lounge

WITH THEIR INSTINCT FOR SOCIAL DISTINCTIONS, their morbid passion for what Americans call self-stratification, the English have divided their pubs up into the greatest possible number of compartments. A London pub can have a Saloon Lounge, Saloon Bar, Private Bar, Public Bar, Jug-and-Bottle, and Ladies' Bar, to say nothing of such refinements as Wine Bars, Lunch Bars, Buffet Bars, and Dives.

Let us start, as is fitting, at the most respectable of all the standard categories – the Saloon Lounge.

The Lounge is standard to the extent that many pubs have one, but it is a refinement on the Saloon Bar. It shows, therefore, that the pub possessing one has aspirations. It caters for a class of people who might not care to be frequenters of the Saloon Bar.

The basis of class distinctions is never more shaky than in the London pubs. The class who use the Saloon Lounge are in no way better than any other class, except that they think their position demands that they should do things in the most impressive way. In the Lounge you drink mostly at small tables. There are waiters who bring your drink from the bar to the table, and depend for their sustenance mainly upon tips. No doubt many people go to the Lounge because they like to sit at a table and talk in comfort. No doubt many more go there because, owing to the necessity of tipping, it is grander than the Saloon Bar.

All the same, the Saloon Lounge is going out. The modern Saloon Bar has the same advantages and the same drawbacks. The Lounge belongs to an older order, like first-class on the District Railway. It is found in its perfection in the old-established houses like the

Warrington, which Ardizzone has drawn.

The Warrington is a landmark in Maida Vale. With a wonderful situation on the corner of Sutherland Avenue and Warrington Crescent, it is a fine building that dominates a whole neighbourhood. Nor has it rested on its laurels and let progress pass it by. A lighted sign on its exterior proclaims the existence here of 'London's Liveliest Lounge'.

That is a proud boast and an interesting claim, for liveliness is a quality not encouraged by the modern Licensing Bench, who take the view that if you must drink you had better drink *sotto voce*, so to speak, and such amenities as music and dancing tend to aggravate the crime. But the Warrington has done its best to justify it by the very lively, very modern, decorations recently grafted on to its historic Lounge.

This Lounge has a magnificent staircase, heavy, old-fashioned, imposing to the last degree. The mere sight of the staircase makes you think of Edwardian revelry, of well-nourished bookmakers and stout ladies in cartwheel hats, of feather boas and parasols and malacca canes, of dogskin gloves and big cigars. Until fairly recently, indeed, you could still find something of this atmosphere in the Liveliest Lounge.

Now, however, the Lounge has been furbished up. The staircase is still there, but the furniture is modern. The blonde barmaids are hardly more up to date than the tables and chairs. The custom has been modernized, too. The frowsy survivals of Edwardian days who still haunt Maida Vale are swamped by the brighter young people who find the new Lounge more to their taste than the old.

You must move with the times nowadays, and the Warrington deserves all credit for keeping abreast. After all, the staircase and the arches are still there for Ardizzone to draw.

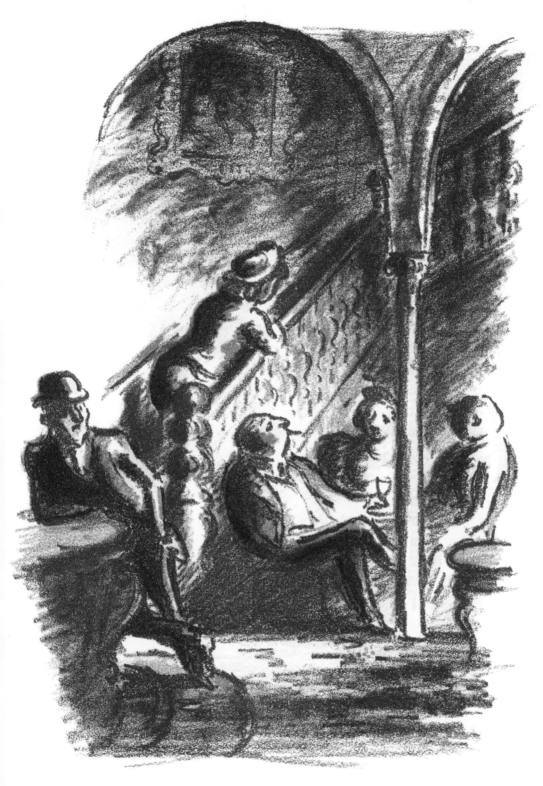

Lounge at the Warrington

The Saloon Bar

ONE OF THE MOST FASCINATING THINGS about the pubs is the way they are carved up, by interior partitions, into the most unexpected and fantastic shapes. It is often quite startling to look up at the ceiling and realize that all these compartments, varying so widely in their geography and in their social significance, are merely sketched on the ground plan of a simple rectangular space.

This is especially true of the older houses. The Saloon Bar may be approached down a corridor running the whole length of the house, or it may have its own entrance round the corner, up a court or down a mews. Everything possible was done, even to the provision of glass shutters in the bar itself, to save the Saloon habitue from realizing that he was sharing his drinking area with his social inferiors in the Public Bar.

Apart from geography, which, of course, varies from pub to pub, the chief distinction of the Saloon Bar is that the drinks cost more. The amount of the tax on social superiority varies, but it may run to as much as threepence a pint. Sometimes there are added restrictions, such as refusal to serve mild ale in the Saloon Bar; while there are Saloons so refined that they do not even serve pints. Generally speaking, however, the management has too much sense to impose such restrictions, which serve only to drive customers into the relative cheapness of the Public Bar.

Like everything else in the pubs, the Saloon Bar varies from house to house. You may have enormous Saloons as in the Windsor Castle at Victoria, small crowded Saloons as at the Warwick Castle, bright, snug Saloons as at the Canterbury Arms in Lambeth Marsh, architectural Saloons as at the Prince Alfred, which Ardizzone was

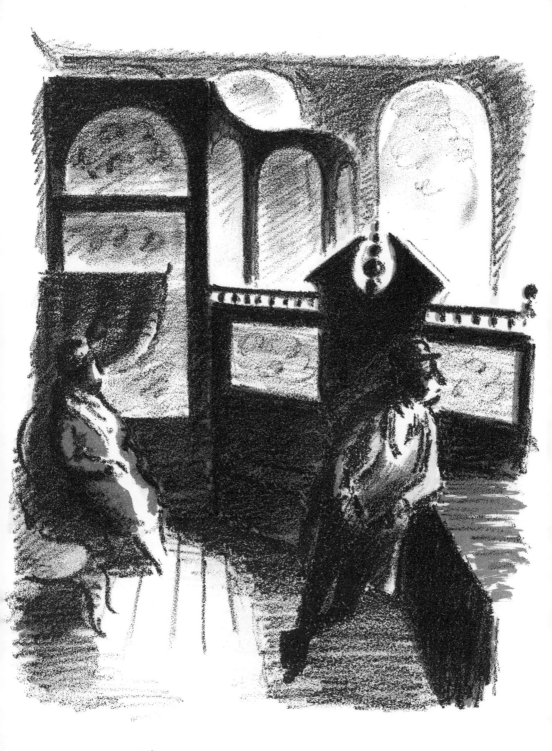

Saloon Bar at the
Prince Alfred

irresistibly tempted to draw.

But the Saloon Bar has certain common characteristics, wherever you find it. It is in the Saloon that you get (according to the period when the house was last done up) the ferns in great brass pots, the bevelled mirrors, the horsehair sofas, the reproductions of *Popularity* and *Derby Day*, the coloured caricature of the landlord done (very cheaply) by a peripatetic artist, the cockatoo in a cage, the open fire, the pintables, the chromium-plated beer-pulls, the snack-bar with a lobster displayed on it, the pretty barmaids, the pewter tankards. And talking about tankards, it may be mentioned that some pubs show their opinion of their Saloon Bar customers by leaving the pint tankards plain, but embellishing the half-pint tankards with false bottoms and bell tops that make them look as though half-a-pint were quite a considerable drink. Incidentally, these tankards are used almost entirely for bitter. In the Saloon Bar, bitter is implied if you ask, without specifying, for a pint or half-a-can.

Finally, the Saloon Bar is the headquarters of the landlord himself. It is here that he chats to the habitues and allows them to buy him drinks. It is here, too, that dalliance with the barmaids is practised in the diminishing number of houses where the barmaids are dallied with. The Saloon Bar is comfort, elegance, and the feeling of doing yourself well; and very pleasant that feeling can be.

There are, however, houses that have no Saloon Bar.

The Public Bar

THE PUBLIC BAR is the cheapest and most plebeian part of the house, where you pay nothing for decoration, and the mild ale costs fivepence a pint. There are no waiters, no hospital collecting-boxes, no pintables (though you will almost certainly find shoveha'penny and darts); you can bring your lunch and eat it without undue comment. In the Public Bar you see more ale sold than bitter, and pints are less the exception than the rule.

Indeed, one of the chief dangers of writing about the pubs is the danger of sentimentally glorifying the Public Bar.

However, the foregoing remarks about the Saloon Lounge and Saloon Bar have tried to explain the merits of these higher-priced compartments. All I can say is that their gilded luxury and almost lascivious attractions make the change to the simple pleasures of the Public Bar all the more enjoyable. After all, you can always change back.

Social distinctions being what they are in England, the Public Bar is by no means open to all. There are many Public Bars where any patron not dressed as a labourer is regarded with distrust. His presence is resented, on the natural grounds that he is a person who can afford to use the Saloon Bar, and therefore his reasons for going elsewhere must presumably be either curiosity or parsimony. Both are motives justly despised in the Public Bar.

As I cannot claim ever to have been a labourer, I must confess that my experience of Public Bars is limited compared with my experience of Saloons. But there are pubs where you are almost forced by the management into the Public Bar. That happened in one of my locals – the Prince of Orange – where a new barmaid

once refused to serve me stout-and-mild in the Saloon, because both brews had to be fetched from the cheap side. That was enough. That let me out. Thence-forward I was free of the Public Bar, and I have been using it with confidence for some ten years.

Then there are the houses that have no Saloon. These can be quite big houses like the Victoria Stores in Brewer Street, already mentioned in this book. There the whole of the licensed area is given up to one partition-less bar, all Public, all cheap. Incidentally, this bar is as spacious and airy, with as much sitting-room and as many tables, as many rebuilt, café-style Saloons.

This is not a typical one-bar house. To find the genuine Saloon-less London pub that might be a country pub you must search in the back streets and the mews. There is no better example than the nest of little pubs in the by-streets between Hyde Park Corner and Hobart Place, centering on Little Chester Street. There a choice of bars is the exception, and it makes the pubs not only much cheaper (for the draught beer drinker), but much nicer. There is nothing more embarrassing than to pass by a well-patronized Public Bar and penetrate decorously into an empty Saloon.

There are, of course, complications about this business of hankering after Public Bars. For instance, there is the darts craze, which drained some of the most unsuitable elements from the Saloon into the Public Bar, so that the locals sat in hopeless apathy while young women with blood-red finger-nails threw doubles with hard-boiled charm; but that has cured itself. What is worse: there are a few pubs in London that, for no good reason, have no Public Bars.

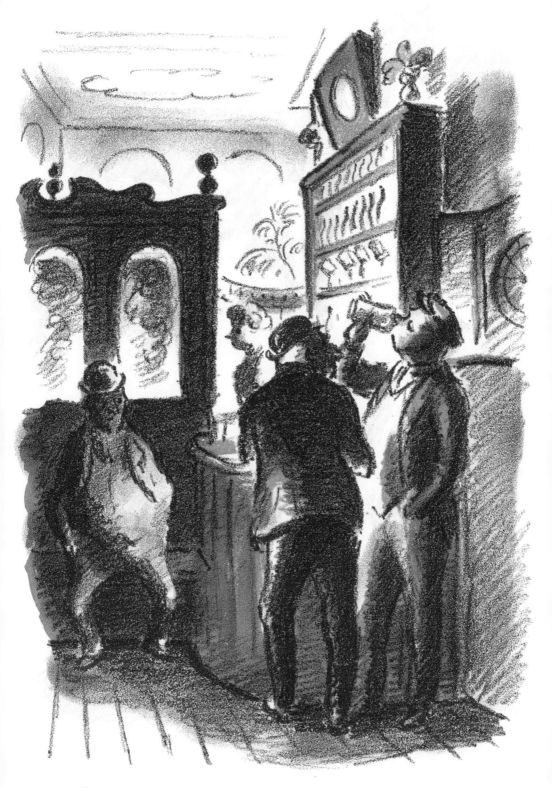

Public Bar at the George

The Jug-and-Bottle Bar

SOME PROGRESSIVE THINKERS talk as though the pubs were a relic of the darkest ages of Victorian Science and the Economic Man. They are usually the same thinkers who point to Hogarth's *Beer Street* and *Gin Lane* as examples of the evils of intemperance, regardless of the fact that all Hogarth was trying to do was to illustrate the merits of beer as opposed to gin. But however stoutly these thinkers are to be resisted on many points, it is hard not to give them best over the Jug-and-Bottle Bar.

The Jug-and-Bottle (or, if you prefer it, Bottle-and-Jug) has the taint of furtiveness about it, which is not shared by the rest of the pub. There is a sort of sneaking assumption that whilst it would be disgraceful to be seen drinking in a pub, it is consistent with respectability to use the Bottle-and-Jug. This hypocritical outlook is further emphasized by the shutters or jalousies that are an almost invariable feature of this under-handed bar. It is sustained by such weak pretences as bringing in the empties in attaché-cases, and taking away the full bottles in brown paper containers not marked with the name of the pub. To such an extent has this hypocrisy gone that most barmen wrap bottles in paper without being asked, even though the practical result may be that in carrying them you keep a firm grip on the paper while the bottle falls to the ground.

One stage beyond the Jug-and-Bottle is the Off-Licence, which is the pub shorn of all its sociability, masquerading as a shop. But the Off-Licence has one important quality that the Jug-and-Bottle has not. Usually it flourishes where there is no pub. It is not a question of choice between going into the Jug-and-Bottle and going into one of the bars, but of choice between going into the Off-Licence and

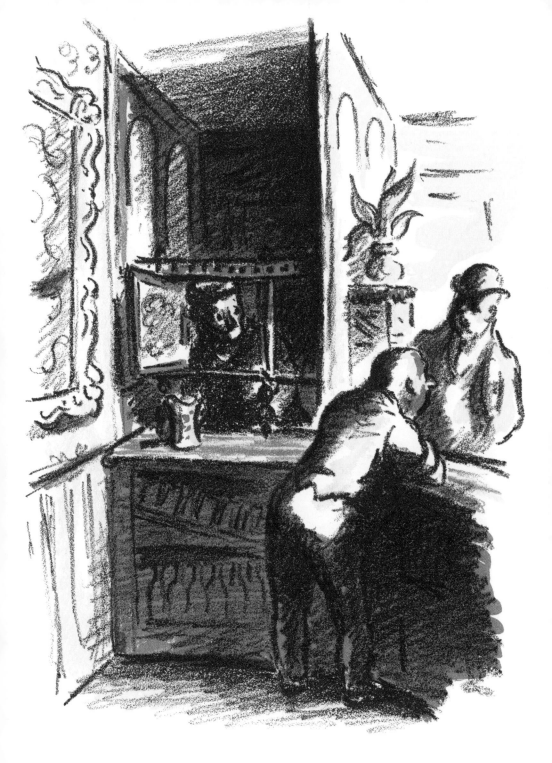

The Jug and Bottle at the Green Man

going without.

All that can be said against the practice of buying or ordering drinks for home consumption has been said long ago by G.K. Chesterton, and practical experience reinforces it, for the drinker on licensed premises is always circumscribed in his behaviour by the licensee's respect for his licence, whereas the drinker at home or on parties is not. It is better to consider the points in favour of buying drink to take away, even if the transaction is not carried out in the Jug-and-Bottle Bar.

The chief occasions for such purchases are, naturally, Saturday night, when the late hour of opening on Sunday morning means an unusually long gap; and Sunday night, when the unusually early hour of closing has the same result. It is really gratifying to the enthusiast to see the amount of drink that is purchased for home consumption, and the large proportion of it that reaches home. In more primitive communities, such as Glasgow, the use of the quart bottle as a weapon is apparently too tempting to be withstood. In London, values are very different. The ordinary citizen would submit to almost any indignity sooner than jeopardize his precious cargo. If goaded beyond endurance, in the last resort he might hand it to his wife.

But the odds are that these treasured quarts were not bought in the Jug-and-Bottle. The need for such subterfuges is past. Untidy women in list slippers may still shuffle into the Jug-and-Bottle for the dinner beer, but the Heir of All the Ages has no scruple about bartering his empties over the genuine, unqualified bar.

Al Fresco

THIS IS A HARD SUBJECT TO WRITE ABOUT, as *al fresco* drinking is, on the whole, discouraged in the London pubs. Indeed, nothing is more familiar than the notice warning you that glasses may not be taken outside. This is due not so much to the natural desire not to lose glasses (though some wayside publicans in the country, who cater for the coach trade, could supply some interesting figures on that subject) as to the illegality of drinking on any plot of ground not licensed by the Bench.

In central London, therefore, with which this book is mainly concerned, *al fresco* drinking is largely confined to the interior lobbies of pubs, in which tired mothers may be seen gratefully drinking the Guinnesses brought to them from inside by considerate fathers, while keeping a sharp eye on little Tommy, who is thirstily drinking a lemonade, also brought from inside, though at a quite disproportionate cost.

For real open-air drinking you must go to the suburbs: Hampstead, Putney Heath, Roehampton, Barnes. There is a pleasant beerhouse on Putney Heath; the Red Lion at Barnes, as you can see from Ardizzone's drawing, has a garden where you can drink without a roof over your head; the Gate at Barnet has the next best thing to an open-air bar – a sort of annexe with a tree growing up through the floor and out through the roof; there are still a few pubs with benches and tables outside, such as the Flask at Highgate; and there are facilities for drinking outside the bar, with an almost rural view before you, at such places as Hampstead's famous Vale of Health Hotel.

On August Bank Holiday the Vale of Health is a wonderful sight.

The drinking area is enlarged by the sort of verandah commanding the view, but on that occasion it could hardly be enlarged enough. Thirsty from the roundabouts, the chairo-planes and boatswings and all the fun of the fair, the people of London flock into the hotel. Getting to the bar is difficult; getting served is a task for a dictator; getting a couple of well-filled pints or bottle glasses back through the crowd is a job for a Cinquevalli with the strength of ten. The fact that legal closing times bear no relation to the duration of daylight helps to swell the panic. The casual drinker who waits for his drink until he wants it fares badly in London. If he does not want to leave the Heath thirsty, he has no choice but to join the throng and start pushing and struggling well before the mystic hour of half-past ten.

Nothing makes the legal regulation of drinking hours look more arbitrary than such a regular but exceptional event as fairs. Mitcham Fair, South London's annual August carnival, is another excellent example. No drink is sold on the fairground itself, so the pubs surrounding it do many times more than their normal trade. Early in the evening they become full, and, defying the right use of words, they get fuller as the fair goes on. Finally the law goes by the board: not the law of closing, which is absolute, but the law about drinking outside. Before the evening is finished, the pubs are positively grateful to anybody who will take his drink out of the bar.

All of which is very different from the leisurely and entirely legitimate enjoyment of a drink in the beer-garden of the Red Lion at Barnes.

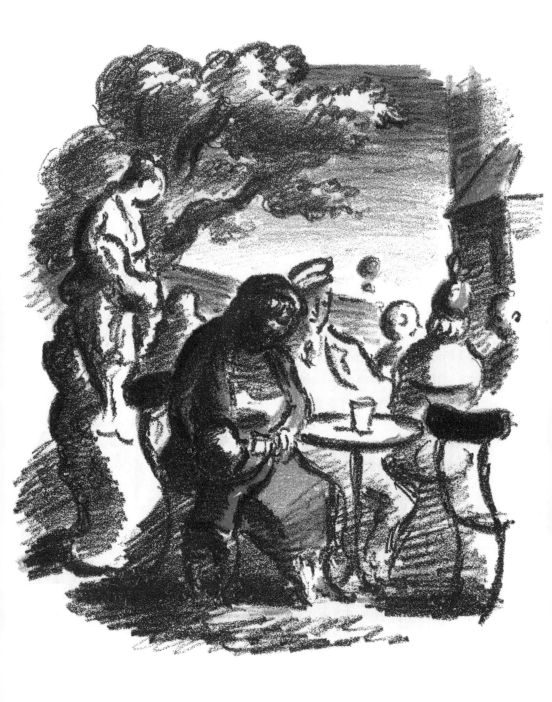

The Garden at the
Red Lion

The Mews Pub

THE MOST OBVIOUS ADVANTAGE of the mews pub is that it lies to some extent off the main track, and you can therefore get a spurious sense of discovery or knowledgeableness out of going to it. Equally, if you are a furtive drinker, its air of secrecy may appeal to you. To turn down the mews and then duck into the pub is less embarrassing to the easily embarrassed than to walk boldly into a pub in the main street.

Apart from these psychological points, pubs in mews often have real advantages. Often you find pubs in the mews when the streets themselves have none, and, on the whole, mews pubs are quieter than pubs in the street.

The value of pubs in mews, up courts, down alleys, and in side streets that are virtually mews, has already been dwelt upon in the Preface to this book. As for their character, it is obvious that they are more likely to be peaceful resorts of local gossips than gin palaces or packed noisy houses where everybody is in a hurry and the cash register rings all the time. They attract not only a quieter type of customer but a quieter type of landlord. The active go-getter does not stay long in the mews. Nor does the brewery spend much of its money in modernizing the mews pub, where there is little passing traffic to attract.

One of the nicest mews pubs I have come across is the White Hart in Brook Mews North, not far from the Bayswater Road. Outside, this house is most unobtrusive; inside, it takes you back a generation or two. Its big bar has been left unmodernised, and though in the last hour of the day you will find quite a lot of up-to-date young people in there, the locals have not been driven out.

48

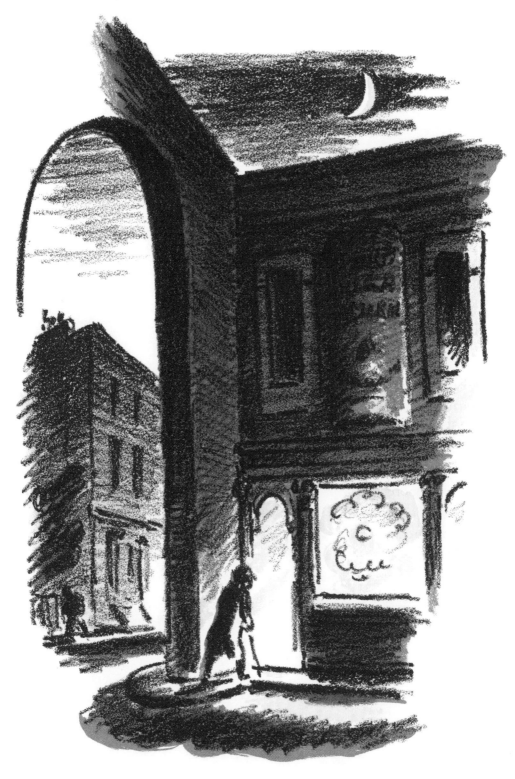

The Lord High Admiral

Incidentally, their beer is brewed by Reffells of Bexley – a brewery that I have never encountered in any other house in the West End.

There are good little pubs in the mews of Belgravia, such as the Stanhope on the corner of Wilton Mews and Little Chester Street, where the little bar is one of the matiest places I know, either on a Sunday morning or on a Saturday night; or the Star Tavern in Belgrave Mews West – a much bigger house that might stand in a country town, approached through a most imposing Belgravian archway. Both these, by the way, sell beers that are not found everywhere in London: Usher's at the Stanhope, Fuller's at the Star.

There is a good mews pub just off Gloucester Road – the Royal Pair on the corner of Clareville Street; and there is an excellent house, large and roomy but pleasantly old-fashioned, just behind Oxford Street – the Three Tuns in South Portman Mews. The Dover Castle in Weymouth Mews, close to Portland Place, was a quiet local house with a livery-stable air about the clientele until the International Broadcasting Company made it its local house. Speaking generally, it is always worth trying the pub in the mews.

As for the houses that are in the same category, though their postal address is a street and not a mews, their name is Legion. You will find them behind Knightsbridge (try Motcomb Street and Kinnerton Street), in Mayfair (where the Coach and Horses and the Running Footman have each a foot in Hay's Mews), most of all behind Fleet Street, where you can dive up and down the alleys and find a pub round every corner, from the rebuilt neatness of the Falcon (where they gave free drinks on the reopening day) to the carefully-guarded venerability of the Cheshire Cheese.

The Wine House

WINE IS NOT THE DRINK OF THE LONDON PUBS. That is not to say that no good wine is sold in them, but it is the exception. Even more than the beer-drinker, the wine-drinker has to know where to go.

Some public houses where they do sell also beers and spirits have a name for good wine. Henekey's houses, for instance, specialize in wine. They also specialize in a style of antique decoration that is much more pleasing to the eye than antique styles usually are in pubs. The big Henekey's in the Strand, near Wellington Street, is a good example of the sort of thing – heavy doors swinging on straps, panelling that looks dark with age, a step down into the bar, and so on. Henekey's in High Holborn is even more old-world, since it has a row of cubicles each containing a table and chairs, which give a comfortable illusion of privacy. There is another big Henekey's in Kingly Street, behind Regent Street, which is a gay scene on Christmas Eve, when the girls from the big dress shops make up parties and buy each other drinks. And there is a smaller Henekey's in Marylebone High Street, which is interesting as showing how the style looks when it is quite new. Only a year or two ago this was the Angel; then Henekey's took it, rebuilt it, and made a very nice job of it, clean and bright in spite of being conscientiously antique.

Other houses where the wine is above the ordinary pub level are Short's houses (e.g., the one near the Gaiety or the one at the top of Chancery Lane), Yates's Wine Lodge (a name better known in the provinces, but there is one in the Strand), Finch's houses (particularly numerous in Marylebone), and the Bodegas (the one

in Glasshouse Street always seems to me the head and front of these). Mooney's houses serve a variety of wines from the wood, so you can get a tall glass of port with a head on it. Other pubs keep a varying selection of wines, the touch of ambition being evident in those where they serve draught champagne, from a bottle kept head downwards, confined by a powerful spring.

The Wine House proper is, however, quite another kettle of fish. It is at once more respectable and more dissipated than the ordinary pub. People patronize it who would not like the neighbours to see them going into the Saloon Bar, but when they get there they drink much more seriously. Wine is surprisingly cheap in comparison with its alcoholic content, and a couple of large ports in the Wine House give a much greater sense of comfort than quite a string of bottled beers.

The people who go to the Wine Houses usually need comfort, too. Middle-aged women predominate – the sort of people George Belcher draws. They sit in the shadow of the great portly casks, exchanging grievances and making alternate trips to the bar, till the grievances seem less formidable, the world becomes less grey, and the prosperous days before they lost their husbands seem less far away.

Of course, there are other patrons of the Wine Houses – from seekers of Red Biddy to needy connoisseurs. There are men out with respectable girls who don't go into pubs, but share the old delusion that port wine is a temperance drink. And there are the new wine bars, such as the one near Oxford Circus, sponsored by Shirreff's, of the big wine-cellars under the railway arch on Ludgate Hill. These are clean and bright and modern, and the most elegant people can go to them. But to see drink used as an escape from tribulation, go to an old-fashioned Wine House in the Edgware Road.

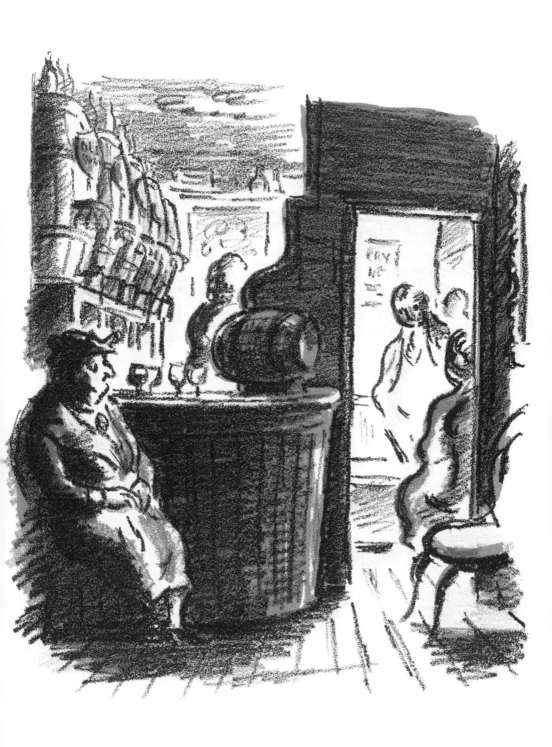

King's Wine House

Eating in Pubs

SOME OF THE MOST PLEASANT EATING-PLACES in London are in the pubs, but you have to know where to go. Otherwise you can walk a long way in search of tolerable food, especially at night.

At midday practically every pub can supply something eatable in the bar, and many have separate dining-rooms or restaurants as well. The most completely equipped pub in London, probably, is the Windsor Castle at Victoria, which has a snack-bar in the Saloon, an enormous snack-bar and waiter-tended tables in the Dive (where you can eat till midnight), a very elegant restaurant with its own entrance, and a Delicatessen attached. At the other end of the scale are the small houses where you can get bread and cheese, and perhaps a ham sandwich or a hard-boiled egg. If the bread and cheese are fresh and good, nothing goes better with beer. The trouble is that they are not always good. You have to know your pub.

Apart from the separate restaurant, the great speciality of the pubs is the hot dinner served at midday in the bar. Very often this is served in the Public Bar (where it is called the Workman's Dinner) at prices so low as ninepence or a shilling, and in the Saloon Bar, with added delicacies, at about one and sixpence. Usually the tables are occupied by the same people every day: regulars who work in the neighbourhood and never think of going anywhere else for their meal. Some of them do not even drink; they may have a mineral water, or a coffee after their meal, or nothing at all. They are wise, though, to eat in the pubs, for a good pub dinner gives you English cooking at its best. There is seldom a choice of more than two meat dishes, but they are the best meat, newly bought, newly cooked,

with all the gravy, and more tasty than many far more elaborate dishes served in restaurants where you pay far more.

Licensing justices, for some reason, look more kindly on separate dining-rooms, such as the one at the Spread Eagle in Oxford Street, which Ardizzone has drawn. There are a lot of these in the West End, some of them very elegant, as at the Wallace Head in Blandford Street, the Masons' Arms in Maddox Street, or the Unicorn in Jermyn Street. Even more imposing are the restaurants of such far-flung houses as the Horseshoe in Tottenham Court Road, which rivals the old-world atmosphere of Fleet Street, though it seems only yesterday that the house was rebuilt; or the Bedford Corner Hotel farther up the road, which has almost as many ramifications as the Windsor Castle itself.

These, however, are almost too grand to be counted as pubs. More typical are the oyster-bar at Ward's, in Piccadilly Circus, presided over by the most cheerful little man in London; the snack-bar at the Horse and Groom in Great Portland Street, where the sandwiches are unexpectedly cheap; or the bread and cheese and cold sausages at Mooney's in Oxford Street, which are so notoriously good that you have to take your turn to get to the bar.

And I cannot resist mentioning Sweeting's fish restaurant in St. Paul's Churchyard (which is not really a pub, though you eat at the counter and they sell draught beer and stout), where you take what you want off the counter, and when you have finished and it is a question of paying, they merely ask you what you have had.

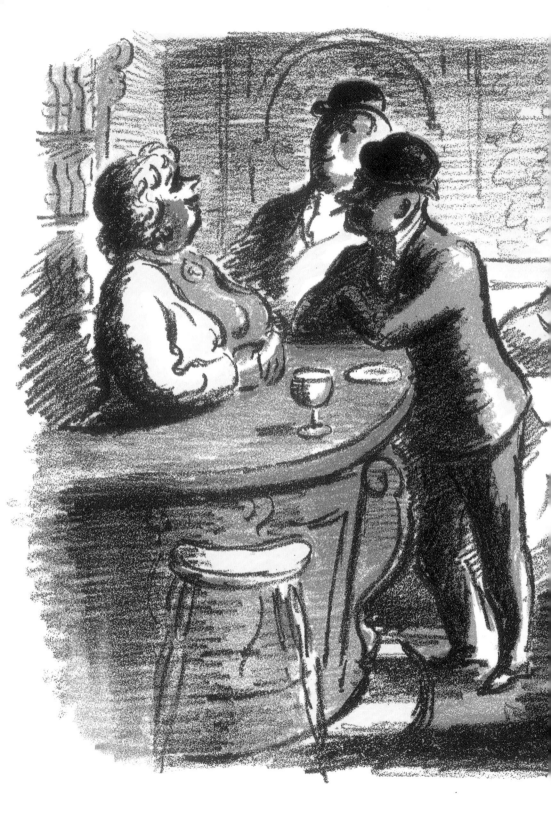

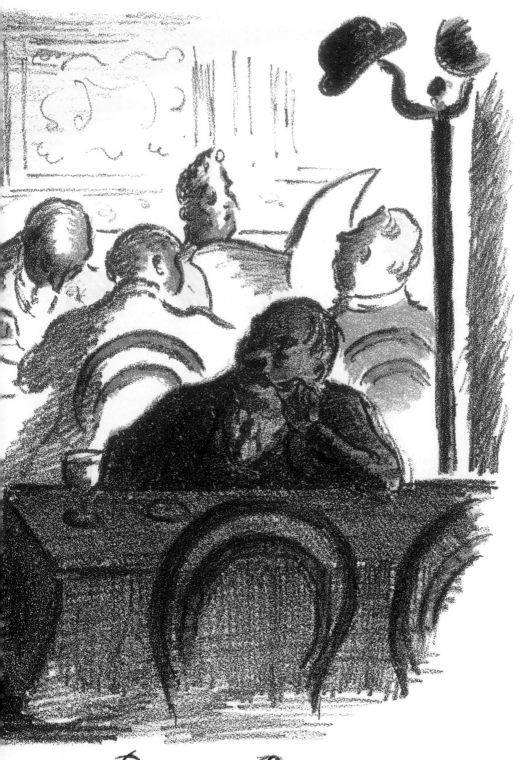

Dining Room at the
Spread Eagle

The West End

A VAGUE TERM IN ITSELF, 'the West End' is even vaguer when applied to pubs. Between Charing Cross and Hyde Park (to adopt fairly narrow limits for the West End) you can find everything from the big corner pub to the pub in the mews. There are houses where they sell nothing on draught except bitter, and houses where the chief call is for mild ale. Some of the homeliest pubs are in the most expensive localities, like the Punch Bowl in Farm Street or the Red Lion in Crown Court, between King Street and Pall Mall. There are plenty of modernized pubs, but none more imposing than those that you see in outlying places like Barnet and Park Royal.

All you can say about the West End is that pubs there are plentiful and varied, providing ample choice for sightseers and theatre crowds. There is a sprinkling of houses kept by notabilities, though these come and go; Jack Bloomfield, the ex-champion boxer, who keeps the Sportsman's Saloon in Bear Street, Leicester Square, is one of the few permanencies. There is, perhaps, a slightly higher likelihood of getting presentable food in West End pubs than in other districts, and a larger proportion of the pubs have restaurants attached. There are very few West End pubs (apart from bars) that do not have a Public Bar, and in the Public Bar the prices are no higher than in any other neighbourhood.

The West End has suffered no more than many other districts from the two plagues that lie in wait for people who like the old-fashioned London pub: modern decoration and the modern clientele.

Modern decoration is a matter that has already been discussed. The modern clientele is even more of a menace. You can ignore the

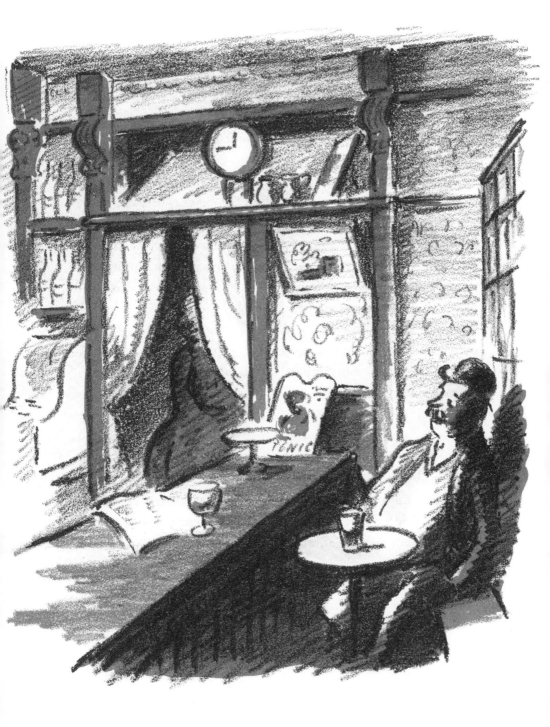

The Private Bar at the Goat

decoration more easily than the clientele. Even the most falsely-panelled walls cannot talk.

It is a terrible thing to see a quiet, ordinary pub in process of being discovered by the bright young people, who are becoming increasingly fond of going to pubs. Their penetrating voices and scarlet fingernails soon come to dominate the Saloon Bar; the craze for darts may even bring them swarming into the cheap side. The pub that caters for them begins to go downhill. The local regulars abandon it and go elsewhere, the staff suffers a change. If redecoration has not already happened, it happens now. At this stage the bright young people often change their habits and desert the redecorated house for another, leaving a wreck behind. Few pubs can thrive on their patronage. If it lasts long it may mean ruin; the sports cars outside the door are as ominous to the licensed house as the hire-purchase vans taking back the furniture are to the home. In extreme cases the end is extinction of the licence and disappearance of the sign, as in the sad case of the Running Horse in Shepherd's Market, which I can remember when it was an ordinary, straightforward, plate-glass-and-mahogany, back-street pub.

There are pubs in the West End that are frequented by young men about town with curled moustaches and a lot of shirt-cuff, by dress-designers' mannequins and photographers' models, by all sorts of people who think they are doing something unusual by going to a pub. But the West End is not alone in this respect, as you can soon prove in Bayswater and Bloomsbury and Chelsea and Marylebone. Whilst in none of these districts will you find a more modest exterior or a cosier Private Bar than in the Goat just off Old Bond Street, which Ardizzone has drawn.

Games

STANDARDS OF BEHAVIOUR in the pubs are very strict. You cannot dance or sing (unless the house has a special licence), you cannot bet or gamble. All the same, pub-goers have at their command a most extensive range of games, and new ones are still coming in.

Darts, shoveha'penny, and dominoes have been played in the pubs from time immemorial. Skittles is vanishing from the London pubs, though I still have happy memories of the alley attached to the King's Head at Roehampton, where they played the old-fashioned, full-blooded game in which you hurl the cheese full pitch at the pins. Billiards, too, is on the decline: not many modern pubs give up the space to it. On the other hand, bar billiards is coming in. Bowls is a rare luxury in the London pubs, though the Six Bells and Bowling Green in King's Road still lives up to its name. Table skittles is found here and there, and the boom of the pintables has swelled the exchequer of many a pub, though the tables are usually confined to the Saloon Bar. I have even come across the ice-hockey game, which is better value than the pintables, in one Saloon – but it did not last long. These fancy importations mostly affect the Saloon. The cheap side seems to remain faithful to dominoes, shoveha'penny, cribbage, and darts.

Dominoes is a quiet, intellectual, rather neglected game. Shoveha'penny is a game of skill about which a lot has been written in recent years. But the game that threatened to bring the greatest changes to the London pubs is the ancient and respectable game of darts.

After being played in the pubs (and hardly anywhere else) for

countless generations, darts experienced a sudden and remarkable boom. From being a thoroughly plebeian game it jumped into the fashion. In no time white-collared workers were carrying their own darts in their waistcoat pockets, dartboards were appearing in smart clubs and in middle-class homes, young women about the West End were playing darts as nonchalantly as bridge. Eminent personages were photographed throwing darts, championship matches were broadcast to the nation. It was a very well-run campaign.

The first effect on the pubs was that people began going to them who had never used them before. The second was that people destined by convention to be Saloon Bar customers began going to the Public Bar. Darts demand long drinks, so dart-players discovered ale. The result was that the long-established social stratification of the pubs was knocked sideways, and the regulars of the Public Bar sat gloomily in corners, talking in undertones, while bright young women with high metallic voices monopolized the board.

It was not long before the pubs rallied to meet the new conditions. Landlords who had welcomed the new custom saw, with dismay, their old customers being driven out, and people who had previously drunk bottled Bass or whisky-and-soda discovering the advantages of wallop at fivepence a pint. The cure was very simple: a dartboard in the Saloon Bar. England being what it is, social distinctions soon reasserted themselves, to the relief of both sides. It is only in the pubs where there is no room for a dartboard in the Saloon Bar that you now find the upper classes invading the Public side – except in the country, where the locals have got used to it and take their revenge by playing the townsfolk and getting their beer free.

But how surprised we should all have been, only a few years ago, if we had been told that one of the points to be impressed upon the architect, when a pub was being rebuilt, was to leave room for the dartboard in the Saloon Bar!

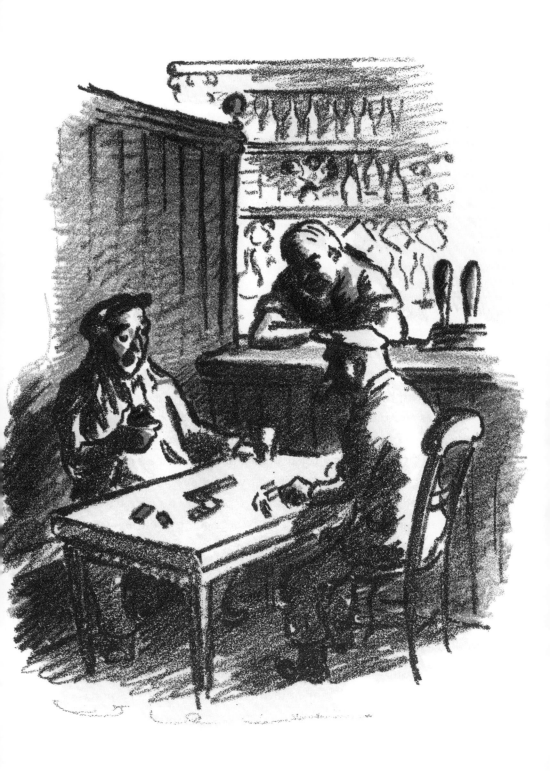

Domino Players

Musicians

PUB-GOERS BEING NOTORIOUSLY GENEROUS, their premises are
continually invaded by mendicants of all kinds. In through
the swing doors come men and women selling (or offering for
sale) bootlaces, matches, collar-studs, books and flowers. There is
one genial merchant whose stock-in-trade varies from enormous
silver watches to try-your-weight on a portable weighing machine.
Salvation Army lasses creep quietly into the pubs they would
like to abolish, and do very well in donations, in spite of their
obvious conviction that they are daring everything for the Cause
by venturing among these evil men. It is a curious sidelight on the
social system that (except for the Salvation Army) these inroads
on the customer's purse are usually allowed to flourish unchecked
in the Public Bar, whilst a curt 'Not this side, please!' checks any
attempt to cash in on the wealthier customers of the Saloon Bar.

Unlike most of these mendicants, who appeal directly to your
charity, are the musicians, who make a point of giving their
performance first, and then coming round to receive what is
technically a thank-offering rather than alms.

One of the oldest sights in London is the performer on the tin
whistle (usually made of brass, I believe, because for some obscure
reason tin whistles are banned by law and brass whistles are not),
with one foot inside the door of the Public Bar, 'demonstrating for
a penny the causes of his professional degradation'. He plays 'By
Killarney's lakes and fells', 'After the ball is over', and perhaps,
by way of demonstrating his versatility, some comparatively recent
hit like 'Little man, you've had a busy day'. Then he takes off his
battered hat and makes a humble tour of the bar.

The Cornet Player

There is a good deal of pathos, and not a little morality, in this incursion of poverty into a resort of comparative plenty. Whatever his real financial standing, everybody feels relatively well-to-do in a pub. Unless you are down to the price of your last drink, you feel affluent, and generous towards anybody who has come in, not to indulge himself with a drink, but to beg from those who can.

The tin-whistle player is, however, the lowest of all pub musicians. There is more self-respect about the cornet, and far more about the multiple band. Whereas the tin-whistle player is merely going through the motions of giving value for the money he hopes to receive, the band is really giving value – whether you like it or not.

There was one combination that I used to hear at the Old Bell, in Exeter Street, close to the Lyceum stage door. They were an accordion-player and a singer, and one or other of them had a wooden leg. The accordion is a powerful instrument, but the singer made it sound like a flute. He sang in the real operatic style, with plenty of *bravura* and all the tricks of the trade. By the time he had torn off a couple of *arias* and bellowed a ballad, nobody's coppers were safe in his trousers pocket. I don't know who he was, but I am sure worse singing has been heard on the stage of many a small Italian opera house. In fact, I am not sure that singing little better has not been heard before on the stage at Covent Garden, not so very far away.

After Hours

'LAST ORDERS, GENTLEMEN, PLEASE!' 'Time, gentlemen, please!' 'Drink up, gentlemen, please!' 'Past time, gentlemen, please!' With this nightly ritual does the law descend on the pubs, always unwelcome, and positively intolerable on Saturday nights.

In the big pubs closing time is pandemonium; in the smaller houses, where the landlord knows his customers personally, it is a gentler affair, but tinged with even more regret. What you can't have you want, and the man who has sat in his corner over half-a-pint all the evening will spring to his feet and fight his way to the bar when the cry of 'Last orders!' rends the air and the lights are lowered as an earnest of what is to come.

It has often been said that limited licensing hours make for drunkenness, and it is true that it is hard to resist the challenge of 'Last orders', however many you may have had. But the best evidence against the arbitrary closing time, whenever it may come, is to be found in the sad groups that gather nightly round the dark and silent pubs.

These are not the people who rush out of the pubs to be sick into the gutter. (This habit is happily on the wane, and the surviving unfortunates, when they recover, stagger hurriedly away.) Nor are they those who cause crowds to collect by giving illusory promise of a fight (and it is seldom now that you see even the promise of a fight either inside or outside a London pub). These are the people who use the pubs; who meet their friends there, talk there, hear the news there, and prefer the cheerful company of the bar to the strait confines of their home. They cannot bear to say goodbye to all that. They linger on the pavement, carrying on the conversations

they have begun in the well-lighted bar, whilst the lights go out behind them, the bolts are shot noisily home, and the iron gates close with a clang.

It is surprising how long they linger there. Half an hour after closing time you can still see them, little knots from which every now and then a reluctant unit detaches itself and slinks solitary home.

On Saturday night they linger longest. On that night the bar is warmest, the greatest proportion of the neighbourhood has met in it, and the gap before it opens again is widest. If the pubs did open earlier on Sunday most of these people would not be up in time to go to them, for the Londoner's long lie-in on Sunday is the great luxury of the week; but at eleven o'clock on Saturday night, 12.30 p.m. on Sunday seems an age away.

There are exceptions to the curfew, of course. There are pubs where they have an extension supper licence until midnight, so that they merely pull down steel shutters over the bar; but you have to pay a shilling for sandwiches to entitle you to a drink, so this privilege is confined to the comparatively well-to-do. The rich have a choice of restaurants and bottle parties where they can drink for hours after the pubs have closed. The provident will have bought beer to take away, or have beer at home – though neither proceeding is regarded with favour by many wives who have no scruple about accompanying their husbands to the pub.

Finally, there is the landlord, who may be glad enough to get to bed on a Saturday night, but who knows that there is nothing to prevent his coming down and having what he likes in the empty, shuttered bar on Sunday, long before 12.30 p.m.

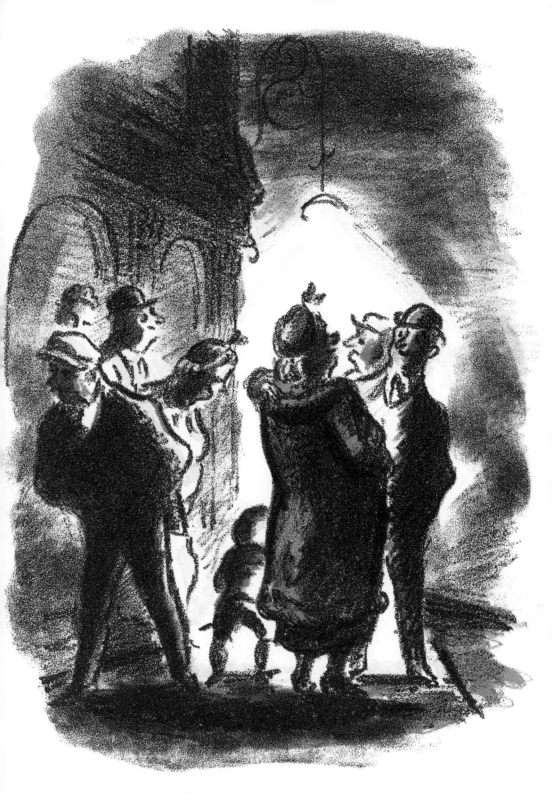

After Hours

Postscript

WHEN THIS BOOK WAS WRITTEN we were still at peace. Before it could be published the war came, and among the tremendous changes it brought one can already see changes in the London pubs.

The lights went first, of course. The enormous lanterns of Victorian gin-palaces, the warm glow through the red curtains of the cosier pubs, the light-signs of the modernized, vanished overnight. If Ardizzone had wanted to draw wartime exteriors he would have had very little to draw.

We grope our way to the pubs nowadays, as though they were speakeasies, and when we get there we find them full of strange patrons – though many a familiar face looks out from over a uniform of police or A.F.S. blue. There have been changes behind the bar, too, as potmen were called up and barmaids went home (very few London barmaids are London girls); there have even been difficulties about drinks, which we have been assured are due to lack of transport and not to lack of beer. But the regulars are still there. With their gas-masks over their shoulders they still sit over their drinks until closing time, though there is now no light streaming from the windows to cheer them on their way home.

Nobody can tell what the war will do to the pubs. Because in the very early days they were the only places where you could find entertainment, the old talk of restrictions sprang up again. With so many everyday institutions overturned by the war, it is too early to worry about the fate of the local. But if the changes should be far-reaching, at least Ardizzone's drawings may serve as a detail for anybody who is trying to build up a picture of London as it was before the war.

Glossary of Terms
Commonly used in Connection
with the London Pubs

ALE. In London pubs, ale stands for Mild Ale, which is the mildest sort of beer. It is reddish-brown in colour, not unlike Burton to look at, but of lower specific gravity. It costs fivepence a pint in the Public Bar, where it is the staple drink. In fact, if you go into the Public Bar and ask for a pint, without specifying the brew, you get ale, just as in the Saloon Bar you would get bitter.

Mild ale is also drunk mixed with bitter (mild-and-bitter), Burton (old-and-mild), strong ale, or stout. Besides the fivepenny there are other grades of ale; for instance, Taylor Walker make a very good special ale called Main Line.

Note: See Brown Ale, I.P.A., Light Ale, Pale Ale, Scotch Ale, Strong Ale, Winter Ale. The preference of literary men for the term 'ale', as being more romantic than 'beer', has caused many misunderstandings. Foreigners, for instance, reading of 'a tankard of ale in a tavern' (instead of 'a pint of beer in a pub') sometimes ask for ale in London pubs, get ale, and think that English beer is extraordinarily weak. Incidentally, ale is not usually served in a tankard in London, as it is chiefly a Public Bar drink, and tankards are seldom seen in the Public Bar.

BAR. Usually a place where drink is sold over the counter for consumption on the premises (but see *Bottle-and-Jug*). The standard equipment for a London pub is three bars – Public, Private, and Saloon – but there are many variations, such as Ladies' Bar, Lunch, Buffet, Snack, and Wine Bars, apart from Lounges and Dives (*q.v.*). The term 'bar' is also used for many places that are not regular pubs, though they may sell draught beer (e.g. the Long Bar at the Standard in Piccadilly Circus), and by some pubs (e.g. Garrett's Long Bar in St. Martin's Lane, formerly known as the Green Man and French Horn).

Note: By Lady Astor's Act of 1923 a bar became known to the legislature as a

place where a person under eighteen years of age may not have a drink, though in a restaurant (if he can afford to go to licensed restaurants) he can have what he likes.

BAR PARLOUR. Formerly a select apartment behind the bar where regular customers forgathered. Now rarely encountered in London pubs.

BARLEY WINE. Specially strong beer, either in bottle or on draught. The best known, probably, is Bass Barley Wine, which is an extremely strong liqueur beer. (See also *Strong Ale.*)

B.-B. An abbreviation for bitter and Burton mixed half-and-half.

BEER. A generic term for all malt liquors; it is sometimes used to include even stout. If you ask for 'beer' in a London pub without specifying what beer you want, you will probably get bitter.

BEER-ENGINE. The machine by which draught beer is pumped from the cellars to the taps in the bar.

BEERHOUSE. A house licensed to sell ales and beers but not spirits. There are not many of these in central London, but the proportion is higher in some outlying parts. For instance, I have come across three in a row in New Cross.

BEER-PULLS. The handles of the beer-engine. In old pubs they are often made of china, with ornamented mounts. In newer bars they are usually of black wood; the last word is chromium plate.

BINDER. A final drink, usually a short one after a series of beers. The progression of drinks for two drinkers might be described as follows: 'Have one with me', 'the other half' (or 'wet the other eye'), 'the odd', 'a final', 'a binder', 'one for the road'.

BITTER. A clear yellow beer, tasting strongly of hops, which is the staple draught drink in the Saloon Bar.

BLACK VELVET. A drink made by mixing champagne and stout; very expensive, but once very fashionable though rather fast. An attempt has

been made to revive it, and some pubs have a notice advertising it and quoting a price. Particularly noted as an excellent pick-me-up for the morning after.

BOTTLE-AND-JUG BAR. A bar reserved for people buying drinks to take away. Selling drinks for consumption at home is quite an important branch of the trade, particularly around closing time, but only big or old-fashioned pubs have a special Bottle-and-Jug Bar, and you can buy bottles over any bar. Bottles are charged for (up to threepence on the quart bottle), so it is important to bring them back. Many people, however, bring their own jugs or bottles (hence the name of the bar) and have them filled from the taps, thus obtaining the advantages of draught beer in the home.

BROWN ALE OR BROWN BEER. A bottled beer corresponding more nearly to Burton than to bitter. Every brewery makes a brown. Occasionally used for Burton on draught.

BUFFET BAR. In pubs this may mean a Snack Bar, or it may be only a grandiose term for a Saloon Lounge or Saloon Bar.

BURTON. A draught beer darker and sweeter than bitter, called originally after the great brewing town of Burton-on-Trent. Burton is also known as 'old'. Popular compounds are B.-B. (bitter and Burton) and old-and-mild (mild and Burton). Some pubs keep a special Burton which is more of a strong ale and makes an excellent mixture with mild, having more body than the ordinary Burton even when mixed. Many pubs do not keep Burton during the hot weather, counting it a winter drink.

CAN. A name for a tankard. 'Half-a-can' – half-a-pint of bitter in a tankard.

CANNED BEER has not caught on in London to any great extent. Some people order it from grocers, but it plays no part in the pubs.

CHASER. A long drink drunk as a complement to a short drink. The name is American, but the habit is well known in the British Isles. In Ireland whiskey is chased with water, in Scotland whisky is often chased

with beer, and English sailors frequently drink rum and Burton alternately, this being a very intoxicating mixture.

CIDER. Most London pubs keep bottled cider, and some have cider on draught. Henekey's specialize in it, serving it in blue mugs. It is very cheap (sixpence a pint) and much stronger than you would think at the time. There are also a few cider houses that sell nothing else; there used to be one just south of the Elephant and Castle, and there is one on the corner of the Harrow Road.

CLOSING TIME. The legal hour at which pubs are compelled to close. This time, like opening time, varies bewilderingly, though certain anomalies have now been removed. (It is no longer possible to be turned out of a pub on the north side of Oxford Street at ten o'clock, cross to the south side, and drink with the barman who turned you out till eleven.) In Westminster (which includes roughly the area between Oxford Street and the River, and between Knightsbridge and Aldwych) the hours of opening are: Weekdays, 11.30 a.m. to 3 p.m., and 5.30 p.m. to 11 p.m.; Sundays, 12.30 p.m. to 2.30 p.m., and 7 p.m. to 10 p.m. No pubs stay open after 11 p.m. for drink alone, though many now have *Extensions (q.v.)*. Certain pubs in the neighbourhood of the markets are open in the early morning for the convenience of market workers, but they are not supposed to serve drink to anybody else.

COCKTAILS. These are not popular in London pubs, and when sold they are frequently poured direct from a bottle, and frequently bad. Who wants cocktails in a pub anyway?

COCKTAIL BARS. Many of these qualify for consideration here by keeping draught beer – usually a keg of Flower's. They very seldom, however, have facilities for keeping it well.

COLD DOG. Sometimes used for cold sausages, which are a popular comestible in the pubs. Unlike 'hot dog', does not imply a roll.

CRIBBAGE is the only card game played extensively in the pubs – usually in the Public Bar.

CRISPS. Cold chipped potatoes, usually sold by the bag. Don't miss the salt, which is in a little blue bag inside the main bag.

DARTS. This game, indigenous to the pubs, has had a remarkable boom in the last few years, and is now played by all classes at home and in clubs and canteens. (Some of the effects of this boom on the different bars of the ordinary pub are mentioned on pages 61-62.) However, it is still mainly located in the Public Bar, unless the pub has a special darts room.

Note: Strictly speaking, all playing of games for prizes in pubs is illegal, but it is the common practice for losers to buy winners a half-pint of ale. This costs 2½d., and if you prefer a more expensive drink you pay your opponent the difference.

DIVE. A downstairs parlour or bar, usually specialising in food (oysters have a traditional association with Dives). There are Dives of every type, from the little snug at the Coal Hole in the Strand to the enormous café-bar at the Windsor Castle in Victoria, and they have little in common except that they do not charge less than Saloon prices. Some Dives do not serve draught beer, so it is always wiser to enquire.

DOG'S NOSE. A name for a rather insidious drink composed of beer with a drop of gin.

DOUBLE. A double whisky (Scotch whisky implied unless you specify Irish or anything else). The ordinary pub measure gives twenty-nine or thirty singles to the bottle, so a double is not very large. The usual price across the bar is 1s 4d., so whisky with bottled soda is not a cheap drink. Of course more than usually elaborate bars may charge more, and restaurants and night clubs charge anything they like.

DOUBLE BROWN, DOUBLE BURTON, DOUBLE STOUT, etc. Names for special brews, but not by any means always to be taken literally.

DRAUGHT beer, stout, cider, or wine is served from the cask with or without the interposition of an engine, but without being bottled first. Draught beer is the characteristic drink of the London pubs, and in my own opinion is far better than bottled beer, as it is usually cheaper and it is not gassy, as bottled beer usually is. It is also the drink that varies most

from brewery to brewery and from pub to pub, and therefore the one that needs most study by the pub-goer.

The drinks kept on draught in the ordinary London pub are bitter, Burton, and mild ale (the mild may be kept only in the Public Bar). To these may be added stout, a special bitter, special Burton, special ale, strong ale or barley wine, lager, cider, spirits, or wine. Most of these are dealt with under separate headings.

DRUNKENNESS is not now habitually encountered in London pubs, and the licensee is usually very much opposed to it, as it gives his house a bad name and may even jeopardize his licence. He will, therefore, probably refuse to serve a customer who seems to have had enough, and he is legally entitled to do this (with certain qualifications: see under *Licensing Laws)*. He may, however, allow a regular customer to exceed a bit if he knows he is not likely to be troublesome, and especially if he is with friends.

EXTENSION. A licence to remain open after the usual licensing hours, on condition that drink is not sold without food. A fair number of West End pubs, for instance, have extensions enabling them to stay open until twelve o'clock at night instead of eleven. There are also occasional extensions for festivities like a Coronation or New Year's Eve, and it is fairly easy to get an extension for private parties, if it is worth the landlord's while to pay the fee.

Note: The sandwiches that you have to order after eleven o'clock so as to qualify for a drink have been the source of innumerable jokes based on the fact that most people do not eat them, so they can be used again and again. These jokes, however, apply mostly to restaurants and cafés. The real joke in a pub is to see them lowering a metal cage round the bar to make sure that nobody can even appear to be having a stand-up drink. The joke is often too subtle for simple untutored drinkers, who make quite a fuss when they are asked to pay a shilling for a sandwich so that they can have another drink.

FOUR-ALE BAR. The Public Bar. The term four ale, though it has no bearing on present-day prices, is still occasionally used for mild ale. Six ale, for the better quality, is sometimes used in the country, but I have not heard it used in London.

FREE HOUSE. A pub not owned or controlled by any one brewer, and therefore free to draw its supplies from more than one source. (Opposed to *Tied House, q.v.*) Free houses are becoming increasingly rare, and most of those now surviving are owned by catering concerns that can compete with the breweries at the game of buying up pubs. Free houses owned by the landlord himself are now very few.

GIN is fairly popular in pubs, drunk with tonic, soda, water, or lime-juice (which has almost displaced the traditional peppermint). In London pubs, gin usually implies London gin, not Plymouth or Hollands. Gin flavoured with Angostura and filled up with water or soda is known as *Pink Gin* and is highly prized as a pick-me-up. Gin is also drunk mixed with French or Italian vermouth (gin-and-It), and with both together. It is seldom drunk neat, and nowadays very seldom mixed with beer (see *Dog's Nose)*.

GINGER ALE is often drunk with whisky or gin (gin-and-ginger), and by itself as a teetotal drink (dry ginger).

GINGER WINE is kept in some pubs and is a very warm and comforting drink. Taken with whisky it makes an excellent cordial.

GLASS. Most London pubs serve everything in glasses, from Scotch to mild. 'A glass of beer' usually means half-a-pint, but some pubs distinguish between a glass and a half-pint, charging a halfpenny less for a glass. This distinction became important during the penny-on-the-pint tax, when quite a lot of pubs reduced the size of the glass instead of adding to the price; though this did not apply to the pint.

PEWTER *(q.v.)* is generally considered to enhance the flavour of draught beer, but glass is certainly better for draught stout. Mooney's, for instance, where the draught Guinness is perfectly kept and served, always use glass pots. Some barmaids do not know this and think they are treating you handsomely by serving draught stout in pewter tankards in the Saloon Bar.

Note: The change in fashions is well indicated by the remark made by one of W.W. Jacobs's characters that the Saloon Bar is a place where you get a penn'orth of beer in a glass and pay twopence for it. Glass and pewter have now changed places.

Glass is now almost universal in the Public Bar, even for pints, and the tankards are reserved for the Saloon, except in one or two pubs in neighbourhoods like the Isle of Dogs, where glass is too dangerous a weapon, and even the pewter mugs are chained to the bar.

GRANNY. A facetious term for old-and-mild, used in the East End and the docks. (Compare *Mother-in-Law.*)

GUT-ROT and Stomach-Wash. Similarly, facetious terms for ale.

HALF-AND-HALF, the old name for ale and porter mixed, is not now used, but if you are ordering anything not altogether usual, such as strong-and-mild, it does no harm to add 'half-and-half'.

HALF-PINT. The ordinary modest glass of beer, holding a sixteenth of a gallon – the most frequent measure for the Saloon Bar. The 'pint' is often omitted when ordering, as in 'half bitter, please'. The ordinary bottle of beer holds roughly half a pint.

HOPS are the element that makes beer bitter. There are now, of course, many hop substitutes, but the big breweries have enormous hop-gardens in Kent.

ICE is not very much used in London pubs, unless they have a cocktail trade. It is still rather a luxury, reserved for very hot weather, when bottles of lager and light ale are placed in a bowl of ice on the bar, and some pubs (though not very many) even cool the draught beer.

Note: Unless the weather is intolerably hot, English beer should not be iced. Beer-drinkers from England suffer terribly when travelling in countries where the beer is iced and has to be drunk in sips (i.e. all countries outside the British Isles), but it is always possible to get the barman to take your bottle off the ice and stand it in hot water before serving, just to take the chill off. This gives Americans a good laugh at the spectacle of the Englishman boiling his beer, but it is worth doing, especially with bottled Guinness, which loses all its flavour when iced.

INDIA PALE ALE. (I.P.A.). A name for Pale Ale *(q.v.)*, derived from the fact that bottled beer exported to India has the sediment removed because it would ferment when the temperature rose above 60 degrees. It is now

fast becoming obsolete; Whitbreads, for instance, dropped the 'India' two or three years ago.

IRISH HOUSE. When a London pub calls itself an Irish House it usually means that it keeps Guinness on draught. Also you are sure of getting Irish whiskey, notably John Jameson. The best-known Irish Houses are Mooney's and Ward's (e.g. Mooney's big house in the Strand, and Ward's house under Piccadilly Circus, with an entrance next to the London Pavilion), but there are others, such as Cribben's Sugar Loaf in Great Queen Street. Some of the Irish Houses are genuine resorts of the Irish in London, and particularly animated on such occasions as the Rugby International, the Grand National, and St. Patrick's Day.

IRISH WHISKEY is not very popular in London pubs. Some pubs are even a bit careless about it, and not above filling up bottles of one brand with whiskey of another, on the ground that it is all Irish, anyway.

Note: Irish whiskey should never be drunk with soda. It is sometimes mixed with water, but the flavour is best obtained by drinking it neat, with the water afterwards, as a *Chaser (q.v.)*.

JUG-AND-BOTTLE BAR. (see *Bottle-and-Jug*, also pages 42-44).

LADIES' BAR. This is a relic of older manners, fast dying out. In pubs that have a Ladies' Bar ladies only are allowed in this bar, and ladies unaccompanied by a gentleman are not supposed to use the other bars. They belong to the era of Phil May and George Belcher, and no rebuilt pub is likely to have one.

LAGER is not a very popular drink in pubs, except in fairly high-class Saloon Bars during very hot weather. One can usually get bottled lager (especially in houses owned by Barclays, who brew an English lager) but it is not always iced. A few houses keep it on draught.

Note: The Prince's Head in Buckingham Street, off the Strand, used to keep lager in summer and stout in winter, and draw the stout through the lager pump. The result was amazingly good draught stout, but I have never encountered the method elsewhere.

LANDLORD. The name is still in use for the licensee of a pub, although he is now usually no more than a nominee of the brewery, or even a salaried manager. This diminution in the real power of the 'landlord' is one reason for the dwindling of individual character in pubs, though it is only fair to say that the publican who is his own landlord can make a house intolerable too.

LICENCE. The licence to sell beers and/or wines and spirits for consumption on the premises is one of the most highly prized of legal rights. There is an awful lot of law about it, but nowadays most houses are owned by the brewers, and they employ celebrated lawyers to protect their interests with the Licensing Bench.

LICENSING LAWS. These laws are responsible for most of the anomalies connected with drinking in London pubs, and local drinkers are apt to consider them particularly unreasonable. Experience of other countries tends, however, to convince one that licensing laws are unreasonable wherever they are in force. You can't order brandy in a Brussels café or whiskey in a Texas saloon, and nothing in London is so comic as the regulation in Washington, D.C., by which you have to sit on a stool to drink beer and at a table to drink whiskey. Nor has London anything quite so prim as the Canadian system of men's and women's bars.

Note: One interesting point about the licensing laws is that the licensee is entitled to refuse to serve any customer, drunk or sober, stranger or regular, in the Saloon or Private Bars, and need give no reason for his refusal. If a customer is refused drink in the Public Bar, however, he can bring the matter up at the next sessions of the Licensing Bench.

LIGHT ALE. A very light bottled beer, usually highly aerated.

LONG PULL. A pre-war custom of giving the customer extra value by serving rather more beer than he ordered and was charged for, killed by the war-time ban on treating and never revived. In fact, the landlord can, under existing laws, be heavily fined for giving either a Long Pull or a Short Pull. A survival of the Long Pull, however, is to be found in the custom by which some pubs, if you start with pints and then have halves in the same tankards, guess the measure and give you a good deal more than halves.

LOUNGE. A superior sort of bar, usually with tables and service, and often without draught beer. (See *Saloon Lounge*, and pages 33-34).

LUNCH-BAR. A bar with a refreshment counter, sometimes offering a really good choice of cold foods. Saloon prices are always charged for drinks in the Lunch-Bar.

MILD ALE. The lightest and cheapest draught beer (fivepence a pint in the Public Bar, though there are more expensive variations). It is the staple drink in Public Bars, where 'a pint' without qualification means a pint of mild. Much drunk by darts-players. Also mixed with bitter, Burton, stout, or strong ale *(q.v.)*. See also *Ale*.

MOTHER-IN-LAW. A facetious name for stout-and-bitter.

MOTHER'S RUIN. Similarly, a name for gin.

NIP. A measure less than half a pint, used for serving strong ales and barley wines (see also *Pony*).

NUMBER 1. A name given by some breweries to their strong ale, both bottled and draught. 'Bass No. 1' is probably the best-known barley wine. These are expensive drinks but very strong, and well fitted for cold weather.

OFF-LICENCE. This is an important rival to the Jug-and-Bottle Bar. Many grocers and wine-merchants have an Off-Licence, but 'the Off-Licence' usually means a special shop kept for the sale of beer for consumption off the premises, where draught as well as bottled beer can be obtained. These are sometimes run in conjunction with a pub, but there are 2,000 separate Off-Licences in the County of London.
Note: The popular opinion of the Off-Licence, as compared with the genuine pub, is perfectly illustrated by the comedians' joke: 'Where did you get married – in church?' 'No – we went to one of those Off-Licence places.'

OLD, in London pubs, is merely a name for Burton. These variants are used quite arbitrarily. For instance, Burton (or old) mixed with mild ale is usually asked for as old-and-mild, not mild-and-Burton or old-and-ale,

but if you want to mix Burton with bitter you ask for bitter-and-Burton (or B.-B), not for old-and-bitter. Euphony probably has a lot to do with this. 'Old-and-ale', for instance, which I have only once heard, is a hard phrase to say and very searching on the vowel sounds.

OLD-AND-MILD gets an entry to itself for purely personal reasons. Unless you have a strong preference for bitter, it is perhaps the safest drink in strange pubs, because the innocuous ale neutralises (or at least disguises) anything that may be wrong with the Burton.

PALE ALE can be either bottled or draught. Bottled, it seems to be the staple product of some modern breweries; it is a clear yellow drink, usually containing a good deal of gas. Speaking very roughly bottled pale ale corresponds to draught bitter, as most breweries do not sell a bottled bitter. When a draught pale ale is brewed, however, it is lighter than draught bitter (e.g. the two brews of Bass).

PEWTER was once commonly used for drinking utensils in the pubs, but in London it has now been largely displaced by glass. Where it is still used it is mostly modern pewter (which is a harder and shinier alloy than the old pewter) and confined to the Saloon Bar. Behind the bar the term is used for the washing-up sink.

Note: One of the few houses that tried to replace its old pewter (which was frequently stolen) with good modern pewter, not too like Britannia metal, was the Cheshire Cheese in Fleet Street. The modern stuff was, however, stolen with such rapidity that they now serve their beer in earthenware mugs. A classic of the old pewter-pinching days is the Phil May joke about the landlord examining a half-crown offered by a really seedy customer. 'I don't so much mind your pinching my pewters,' he says, 'but when it comes to bringing 'em back in the shape of 'arf crowns it's a bit too much.'

PIG'S EAR (rhyming slang for beer). Name for bitter, as opposed to ale.

PINT. Pints were once the ordinary measure for draught beer, and in the Public Bar they are still the most usual order, but in the Saloon they are going out. In fact there are occasional houses so select that they do not keep pint pots or glasses in the Saloon Bar. Prices vary from fivepence a pint for mild ale in the Public Bar to tenpence or more for bitter in the

Saloon. Strong beers and special Burtons, of course, cost more.

PINTABLES have made their way into the pubs in the last few years, and so long as they pay the landlord they are likely to stay. They serve the purpose of getting the customer to stay on after he has had his lunch or his drink, and of course they are even more profitable if the customers are playing for drinks. There are strict laws against any kind of gaming in pubs, so if the landlord does give a packet of cigarettes for an outstanding score it has to be done on the sly.

Note: A whole history could be written of the pintables, their rise from the original Corinthian bagatelle (with a mechanical striker substituted for the pusher) to the most elaborate electrical machines that count your score for you as you go along. Lately they have become, if anything, too elaborate and too varied. The best types were those in which you could build up a score by means of double-actions and replays, but the most maddening of all is one that I have seen only at the Finch house in New Cavendish Street, which has magnetized pins.

PONY. A measure smaller than a half-pint (usually a gill) obtainable in a few pubs, and used mostly for a last drink taken as a gesture of goodwill when the drinker does not really want any more.

PORT is surprisingly popular in the pubs. Both men and women drink it, the latter often under the influence of the old belief that it does not rank as an alcoholic drink.

PORTER is practically obsolete in the London pubs, though its name survives on the beer-pulls of some unmodernised houses, and it is still sold in some off-licences. It was originally to stout as X is to XX, and in that sense it is still widely popular in Ireland.

POT. Formerly, a name for a tankard. Now, a term signifying a quart, used in the Off-Licence trade.

PRIVATE BAR. A compartment half-way between the Public Bar and the Saloon Bar, now tending to disappear. Where it is found it is rather apt to deputize for the Ladies' Bar (q.v.), though there are pubs where it is the best bar in the house.

PUBLIC BAR. The plebeian side of the pub, where everything is cheapest, where nothing is charged for decoration, where pints of ale are the most popular drink, where there are no pintables, and darts, shoveha'penny, and dominoes are played by people who have played them all their lives (see pages 39-40).

PUBLIC HOUSE. Throughout this book the terms 'public house' and 'pub' have been used loosely for places where they sell alcoholic drinks on draught and in bottle for consumption on the premises. This is the sense in which they are used by the ordinary man. Technically, however, there is a distinction between public houses, which are licensed to sell all kinds of drink, and beer-houses, which are licensed for beer but not for spirits. Hotels and restaurants, and off-licences, are separately classified again.

QUART. A quarter of a gallon, or two pints. Quart measures were once common in London pubs, but they are now rarely used; in fact I know of only one house (in the Earl's Court district) where they are habitually served. Many other houses have quart tankards for display purposes, which can be taken down and dusted if they are really required.

Note: English quarts are four to the gallon, whereas American quarts are five to the gallon. This causes a good deal of misunderstanding. For instance, Americans call an ordinary bottle of whiskey (five to the gallon) a quart, although it is nearly half a pint (English) short of an English quart. The American pint, also, is a tenth of a gallon instead of an eighth, which makes quite a difference.

QUARTERN. A measure for spirits, not now in common use in the pubs. Before 1914, a large Scotch was a quartern, and a small Scotch a half-quartern. Wartime restrictions brought in the 'Lloyd George measure', which worked out at six 'drops' to the quartern, the drop being what we have since known as a single. Comparison of these quantities helps one to realize how much more serious an affair drinking must have been before the last war.

RED BIDDY. A drink made of cheap red wine fortified with spirits, which became popular some years ago. For its price it was extremely intoxicating, and it had the quality (like bad potheen) of making its addicts fight. The nature of this drink is well indicated by its nickname – Lunatics' Broth. It

was a real scourge in Glasgow, but it never got the same hold in London.

RINGS. A game played by throwing rings at hooks in a board hung on the wall, which was once played extensively in the London pubs but has now quite gone out.

ROUGH. Strictly speaking, the beer in the drip-cans, made up of residue from the bottoms of bottles and overflows from glasses of draught, which is not normally sold in London pubs. Colloquially used for the cheapest beer (i.e. ordinary mild ale), and with a more clearly facetious bearing for other drinks. If you ask for a can of rough in a West End bar where they sell only bitter, you will get bitter; but before asking for it in an ordinary pub it is as well to be sure the landlord knows what you mean. This use of the word has no connection with Rough Cider, which, so far as I know, is not sold in London pubs.

RUM is perhaps the least popular spirituous drink in the London pubs, though taxi-drivers drink it, and rum with hot water is highly regarded as a cure for a cold. 'Rum' normally implies Jamaica rum; Bacardi is unknown outside the cocktail bars.

SALOON BAR. The superior bar in an ordinary London pub (see pages 36-38).

SALOON LOUNGE. A refinement on the Saloon Bar (see pages 33-34).

SCOTCH. The usual abbreviation for Scotch whisky, the most popular spirituous drink in the London pubs. The half-dozen or so most-advertised brands are to be seen in every house with a spirits licence.

SCOTCH ALE. A brown beer rather resembling Burton. In the London pubs the term almost invariably stands for Younger's Scotch Ale, in bottle or on draught. As this is a very popular brew it is often to be found in free houses, where it usually replaces a Burton, though there are pubs that sell both. Younger's Scotch Ale is their No. 3. Their No. 1 is a really strong brew.

SCOTCH HOUSE, or Scots Hoose, is a name anybody can use, but in

London it is likely to mean a Younger House, where you may find a lot of tartans and a slightly olde-worlde air, but you will certainly find their Scotch Ale on draught.

SHADES. Originally a generic term for cellars, now the name of one famous pub at Charing Cross and of various London bars. When used for one bar in an ordinary pub, roughly equivalent to *Dive*.

SHANDY, composed of beer and ginger-beer or beer and lemonade (lemon shandy), usually mixed in equal proportions, is a popular drink in hot weather, and is drunk at other times by those who do not want to drink too much beer.

SHERRY is drunk in pubs more extensively than any other wine except port, but it varies vastly in quality (see *The Wine House*, pages 51-52).

SHOVEHA'PENNY has been played in the pubs from time immemorial, and it is a very skilled game. It has one advantage over darts in that it can be played in a very small space – wherever there is room for a table, in fact, as hardened players do not seem to mind being jostled from behind.

SNACK BAR. A bar specialising in food, particularly cold food – sandwiches, cold cooked meats, crab, lobster, etc. Saloon prices are charged for drinks in the Snack Bar.

SNUG. An Irish term for a semi-private compartment in a pub, the nearest equivalent to which is a bar parlour, or the sort of inner sanctum you find in the Devereux or the Goat.

SODA-WATER is drunk extensively in Saloon Bars, etc., with all kinds of spirits – whisky, gin, and brandy, and even rum. In hot weather it is occasionally drunk with beer, either beer with a dash of soda or, more often, soda with a dash of beer.

SPLASH. A tot of soda-water from the siphon, usually given free; as opposed to the bottled brands.

STOUT in bottle is served in all London pubs. The most widely drunk

stout is Guinness, but most breweries have their own brands and sell them in their own houses, often at prices considerably below that of Guinness. Draught stout is less common than it used to be, as it requires careful keeping and a fairly quick sale. In many Watney houses, for instance, where Reid's stout in bottle is extremely cheap, it is not worth their while keeping draught stout, though they will often pour you a glass from the quart bottle, which is not very different from draught. The great resorts for draught stout are Mooney's houses, where the draught Guinness is well kept and carefully served – in which conditions it is unique among long drinks.

Note: Draught stout can be mixed with mild or bitter, and if the stout itself tends to be sweet or soupy, a dash of bitter (about a fifth, if you can control the barmaid when she is serving it) improves it a great deal. Stout is, of course, largely drunk with oysters. It is also mixed with champagne to form *Black Velvet (q.v.)*.

Note 2: Stout has a considerable export market, as I discovered on my first visit abroad, when a waiter in the buffet at the Gare de Lyon, spotting my pronunciation of 'bière', asked me whether I wanted *pell-ell ou stoot*. It is curiously appropriate to hot climates, and I found a bar in Havana where the proprietors, one of whom was English by origin, kept baby Guinness for their own consumption, and were not over-pleased when I cut in on their supplies. To complete the travelogue, I had a remarkable experience in a casino bar in Normandy before the season, when the barman asked me how long bottled stout would keep. I said that if kept properly it would keep for ever, and he divulged that he had half-a-dozen of Bass's stout (which is brewed primarily for export) in the cellar, and they had been there when he took over three seasons ago. We had them up and drank them between us; they were very hard to pour, but when you got a glass-full it was nectar. Our reaction was so conspicuous that the local people began ordering stout too, but they got the current vintage, and could not make out what our transports were about.

STRONG ALE or BEER. Sometimes 'strong ale' is merely a pseudonym for the ordinary Burton, which is not particularly strong. However, nearly every brewery has a good strong ale, and if you see a little barrel on the counter marked with an unusual number of X's (or K's) and find that it costs a good deal more than the ordinary draught beer, it is usually worth trying. Most houses where they keep strong ale on draught keep it only in the winter. Famous strong ales are Bass No. 1, Younger's No. 1, and Benskin's Colne Spring. The last, which is a bottled beer, is the joy

of connoisseurs. Benskin's licensees are not supposed to serve more than four bottles of Colne Spring to any one customer – and four bottles is quite enough.

SWIPES. Waste beer; used colloquially for ale, etc., like *Rough*.

TANKARD. A drinking-vessel with a handle, as opposed to an ordinary glass. Tankards, where they are still in use in the London pubs, are usually made of pewter, but they may be made of earthenware or even glass. (See *Can, Pot.*)

TEETOTAL drinks are supplied in all pubs, though naturally the bigger houses have a more extensive range. Soda and tonic water are sold wherever spirits are sold, and houses catering for mixed custom sell things like grapefruit juice, tomato juice, and orangeade. You cannot count, however, upon walking into a pub and obtaining a cup of tea on demand.

TIED HOUSE. A pub in which one brewery has the monopoly of supplying the drinks. Most London pubs are now tied. (See *Free House.*)

TONIC WATER is drunk extensively in the pubs, mostly (though not entirely) with gin.

'THE TRADE' is an expression used in political and sociological discussions to represent the whole of the interests benefiting financially by the sale of drink.
Note: As there is so much politics about anything to do with drinking, it might be as well to state explicitly that this book has been neither inspired nor encouraged – much less subsidized – by the Trade.

WALLOP. A name for mild ale, particularly used by dart-players.

WHISKEY and WHISKY. Correctly, whiskey is Irish and American and whisky Scotch. The latter is very much more popular in London pubs, and most houses keep all the better known proprietary bottled brands. Irish whiskey is not much drunk outside Irish houses. There is one well-known brand of Canadian rye, but I cannot remember ever seeing a Bourbon in a London pub. (See *Irish, Scotch.*)

Note: The Scottish custom of putting whisky in beer is almost unknown in London. I once had to interpret, in Mooney's in the Strand, between a K.O.S.B. man, who wanted to order two pints of beer with whiskies in them, and the Dublin boy behind the bar, who had never heard of such a thing.

WINE can usually be obtained in London pubs, but it is not always wise to drink it (see pages 51-52).

WINE BAR. A bar where they specialize in wines, spirits, and liqueurs. Bottled beer is usually sold in the Wine Bar, but not draught beer. The price factor makes the Wine Bar even more select than the Saloon.

WINE HOUSE or WINE LODGE. A pub specialising in wines, or sometimes a house selling wines only and no draught beer (see pages 51-52). On the whole, Wine Houses give much more wine for the money than you get in an ordinary pub.

WINTER ALE. A name for a strong ale; these brews are usually not sold during the summer, as they are heating, and less in demand. A more precise term is October Ale.

WOMPO. A name for the best ale, used in the East End and around the docks. Origin uncertain – so far as I know.

WOOD. Beer from the wood is beer drawn directly from the cask, with an ordinary tap, as opposed to beer pumped up by means of a beer-engine. Many connoisseurs think that this vastly improves the flavour of the beer. Wine can often be obtained from the wood, and spirits sometimes, the distinction here being that it is drawn direct from the cask without having been bottled.

WORKMAN'S DINNER. A midday meal served in many Public Bars, consisting mainly of a cut from the joint and two veg (see pages 54-55).